Teachers

Teachers was produced by
Lionheart Books, Ltd.
5105 Peachtree Industrial Boulevard
Atlanta, Georgia 30341

Project Director: Deborah Murphy
Design Director: Carley Wilson Brown

ISBN: 0-7407-1940-8

Library of Congress Control Number: 2001090268

ATTENTION: SCHOOLS AND BUSINESSES

Andrews McMeel books are available at quantity discounts with bulk purchase
for educational, business, or sales promotional use. For information, please write to:
Special Sales Department, Andrews McMeel Publishing, 4520 Main Street, Kansas City, Missouri 64111.

Teachers

A TRIBUTE TO THE ENLIGHTENED ★ THE EXCEPTIONAL ★ THE EXTRAORDINARY

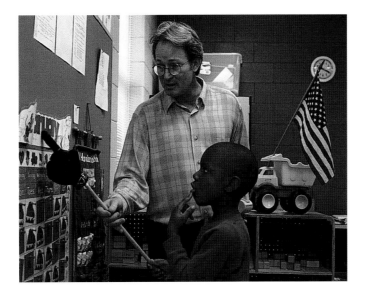

Text by John Yow

Photographs by Gary Firstenberg

Andrews McMeel
Publishing

Kansas City

Introduction

When I was approached with the idea of documenting the finest teachers in America, I jumped at the opportunity. An itinerary that includes New England's mosaic tapestries, the lush forests of the Oregon Coast, the Grand Tetons' snow-covered peaks, and the monolithic canyons of Utah is a photographer's dream. Additionally, this would be no ordinary trek through scenic America, but one with a distinct purpose.

Approaching this project with a positive attitude was easy; after all, the influence of teachers remains with us throughout our lifetimes. Education is acknowledged as the basis for creative thinking, keeping life fresh and interesting. This attitude, coupled with a road-warrior's philosophy of making the least of the worst and the most of the least, set me off on a journey of 50,000 miles in four and a half months through forty states. Our fascination with the subject of teachers, as well as with the individuals who participated in this book, increased over the life of the project.

The list of teachers that were identified as potential interview subjects grew exponentially, and communication and scheduling reached a frenetic pace. Fortunately, teachers are by nature dependable. As the schedule was fast-paced, timing became very important. Every interview and photo session went as planned, despite a few rough rides along icy highways. The first session took place in New York with Dr. Walter Turnbull, the musical director of the Choir Academy of Harlem, who has had an enormous impact on the music of his community and of the larger world. Photographing this charismatic man at work, while being able to hear the amazing harmonies of the choir, confirmed the belief that we were onto something extremely special.

The variations in school settings are as pronounced as the differences that exist throughout America. The extremes ranged from one-room school-houses in rural areas to heavily populated urban blocks. One rural Montana school had mountain lions that stalked the area at night. In urbanized areas a different type of danger, drug- and crime-related, stalks schoolchildren as its victims. In both rural and urban schools, a child's world is profoundly shaped by media influences. Teachers remain increasingly important as positive influences on that world.

Every school we visited was different, and every teacher unique. Sessions took me from an art class in Martha's Vineyard to a school for circus performers in San Francisco. I visited a rodeo school, Space Camp,

and the music teacher who inspired the film *Mr. Holland's Opus*. These marvelous educators taught a large variety of subjects. All are teachers who stand above the norm and possess a unique outlook on their subject matter, often using innovative approaches to present their programs to their students. Many of the teachers substituted hands-on studies for textbooks, and encouraged interaction with all of their students. The shared characteristic of the teachers in this book is that they possess a persistence, focus, and passion for what they do. They are enthusiastic leaders who generate sparks of discovery. The best teachers are those who make demands on their students. It has been said that there are no shadows on a mountaintop. Each of the teachers in this book stood tall on their mountaintop, encouraging students to learn more about a subject, explore new ideas, and see every angle of that subject with enthusiasm. Most importantly, every teacher, no matter how tough on the exterior, demonstrated an unconditional love for the subject matter and for the students in their classes.

This book captures moments of passion and dignity in the teaching profession and sheds light on the impact of some very great teachers and human beings. We hope this book allows you to reflect upon those teachers who have had an impact on your life, who molded and shaped your thinking, and whose efforts have enabled you to succeed in this challenging world.

This book celebrates great teachers. As you reach the final page, please consider that it is not the end of this journey. It is just the beginning.

—*Gary Firstenberg*

Nikki Bowers

Boonsboro Elementary School
Boonsboro, Maryland

"What I love best is seeing the light bulb come on when a child just finally gets it."

Choosing a profession was not difficult for Nikki Bowers. "I became a teacher because I've always loved school," she says. "Ever since I was a little girl, I couldn't wait to get to school in the morning. And now, as a teacher, I still can't wait."

Bowers's infectious enthusiasm is reflected in her philosophy. "The most important thing is to put the kids first," she explains. "To put your own ego aside and look out for the child's ego." Then the next step becomes possible: "You have to put yourself inside the child's world, to see what they see, and to understand what interests them."

And at that point, Bowers says, you can begin to teach: "Now I can get their attention, and I can get them excited about what they're learning. That's the key."

Like many educators today, Bowers faces the daunting task of preparing her students for a statewide assessment test, and as many teachers have complained, "teaching for the test" can be the death of all classroom creativity—and all real learning. She sees it otherwise.

"Well," she says, "you can teach for the test, or you can make it really fun. I first tried to think of something they all enjoy, and then I tried to figure out how to integrate all the subject areas around that source of enjoyment."

The result: her innovative "Toys for Sale" project.

It works like this: The students begin by conducting research surveys concerning what kinds of toys are most popular. They do cost analyses to determine how expensive their selected toys would be to build and how much to charge for them. Next, they construct their "prototypes" (rubber-band powered boats, for example, or marionette crocodiles) and at the same time create advertising campaigns to woo potential customers. At the end of the unit, the class hosts a "toy fair" where the products and their advertising are put on display. The ultimate evaluation comes when students from the other grades arrive at the fair with twenty dollars of "fun money" to spend on the toys they like the best.

"You're integrating language arts, problem solving, economics, math," Bowers says. "Everything is there. And the best thing is, the kids are so excited about it they can barely sit in their chairs."

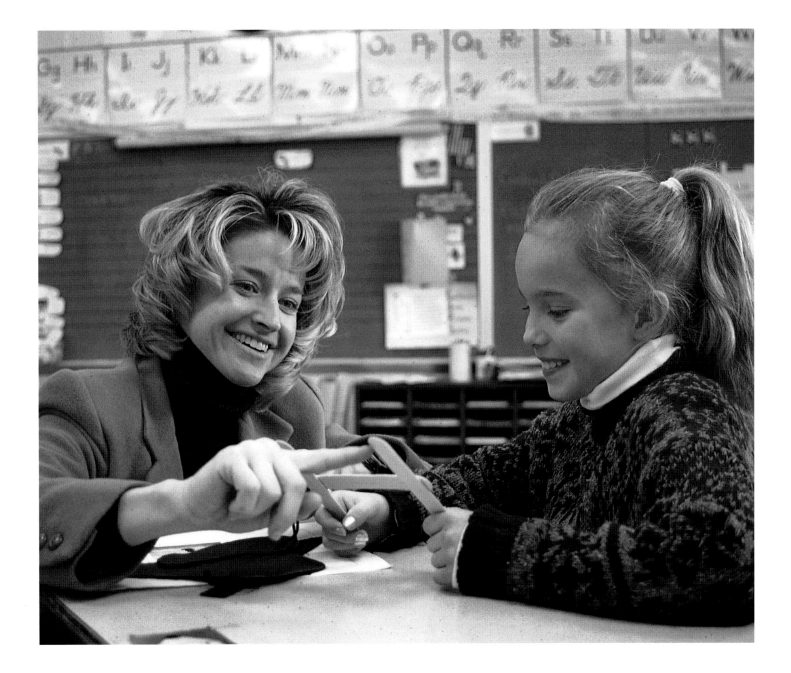

Kelly Monahan-DiNoia

Latin Teacher, Bristol Central High School
Bristol, Connecticut

"Out of the circle of friends I had in college thirteen years ago, I'm the only one who still loves her job."

Don't bother to apply for the position of Latin teacher at Bristol Central High School in Bristol, Connecticut. That job is taken, thank you, and nobody is expecting a vacancy for the next few decades.

As current Latin teacher Kelly Monahan-DiNoia explains, it's a job that doesn't come open very often. Forty-plus years ago, Loretta Teevan was hired, taking over the classroom at Bristol Central where she herself had studied Latin as a high schooler. When Ms. Teevan retired in 1998, she hand-picked Kelly, who had been her student ten years earlier, to take her place.

Two years later, in 2000, Kelly was named Bristol's Teacher of the Year, and thus became ensconced in the position to which she seemed destined.

Simply because her high school Latin teacher "was so wonderful," Kelly recalls, she decided to major in Latin and Ancient Greek at Trinity College in Hartford, but her ambition was to be a lawyer. "I wanted to get certified to teach, to have something to fall back on," she says, "but I had taken my LSAT and was all set to enroll at UCONN as a law student."

But a funny thing happened on the way to law school. "I had one last thing to do to finish my teacher certification—my practice teaching. So I came back here to Bristol Central to teach with Ms. Teevan, and I just loved it. The first time a student said to me, 'Hey, I get it! Thanks,' it was a total epiphany."

Kelly never looked back. After ten years in the East Hartford district, where she was also named Teacher of the Year, she returned home to Bristol Central to the classroom—and the role—Ms. Teevan had prepared her for.

And there you'll find Kelly in her element, sometimes wearing tunic and stola, with a laurel wreath on her head. Her classroom is Italy, complete with a statue of Minerva, photos and illustrations of historical sites, maps of Rome, Florence,Venice, and a parrot named *Beata* (blessed by the gods), whom the students are trying to teach to speak Latin.

Best of all, Kelly says, is that she has been able to take her students to Italy three times in five years. Nothing beats the look on their faces when they step inside the Colosseum for the first time, or stand on the pyre where Julius Caesar's body was immolated. That's because real teaching, according to Kelly, is making the subject come alive. "You have to make it exciting. The days of 'chalk and talk' are long gone."

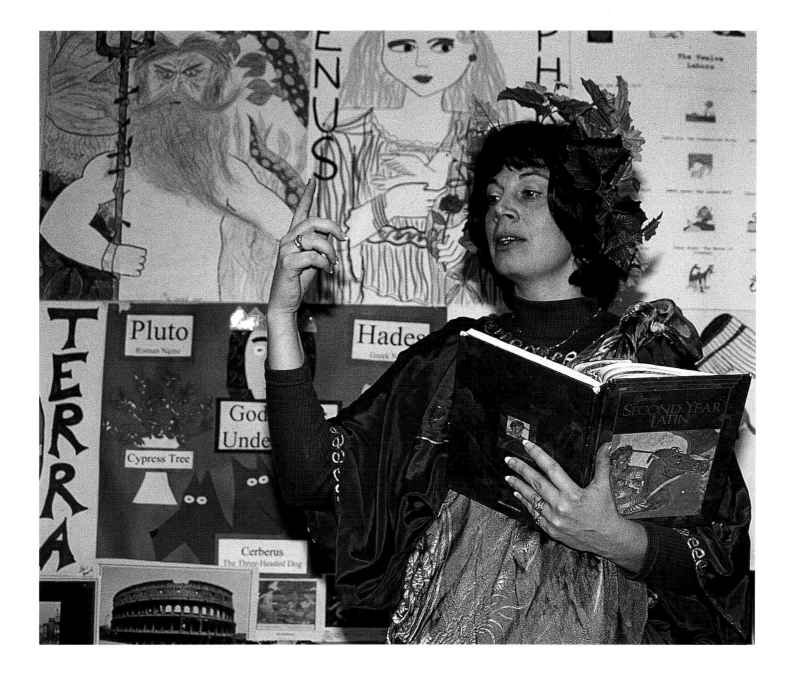

Dr. Walter Turnbull

The Harlem Boys Choir
New York, New York

"Being poor is not an excuse for not succeeding."

If you were asked to name a famous American musician that was born in the Mississippi Delta, Dr. Walter J. Turnbull might not be the first name to spring to your lips. But there can be little question that Dr. Turnbull, a native son of Greenville, Mississippi, and founder of the Harlem Boys Choir, has had a more direct and more profound influence on the lives of more people than any half dozen legendary Delta Bluesmen combined.

Founded in 1968 as the Ephesus Church Choir with twenty boys, the Boys Choir of Harlem (now incorporated to include the Boys Choir of Harlem, the Girls Choir of Harlem, and the Choir Academy of Harlem) today enrolls 560 boys and girls in an artistic and academic curriculum spanning grades four through twelve.

Along the way the Harlem Boys Choir has achieved international renown. Hundreds of thousands enjoy the choir's 100 live performances around the world each year; millions more see them on television or hear their recordings. Among their countless accolades, the Boys Choir of Harlem was awarded the prestigious National Medal of Arts in 1997.

As for Dr. Turnbull, the list of prizes and awards bestowed upon him is endless, but is perhaps epitomized by his being named "One of the 15 Greatest Men on Earth" by *McCall's* magazine. He has been profiled often in print and appeared on virtually every national news and television interview show. He is also the author of the bestselling book, *Lift Every Voice: Expecting the Most and Getting the Best from All of God's Children.*

How did this happen? How did this impoverished child from the Deep South become a beacon of light shining throughout the world?

"Yes," says Dr. Turnbull, one of four children raised by a single mother, "we were very, very poor, but really quite rich—rich in character and, especially, in having a sense of hope. The sense of hope is what we always had, and that has much to do with what the Harlem Boys Choir is today."

Aspiring to become an opera singer, Dr. Turnbull graduated from Tougaloo College in Mississippi and came to New York to attend graduate school at the Manhattan School of Music. He received his Masters and started teaching music to junior high schoolers in the Harlem public school system.

"But then," he says, "the Boys Choir of Harlem hijacked my life."

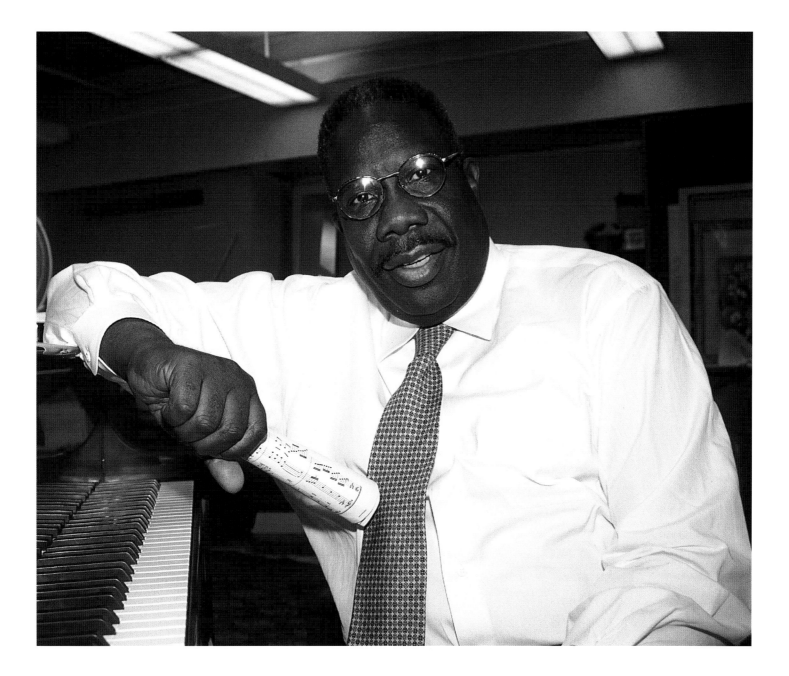

Becoming a teacher "snuck up" on him, Dr. Turnbull says, while he was still angling toward a life in opera. "I saw the kids get excited once they became involved in music, and the idea of helping them develop as human beings, helping them to become good musicians or great mathematicians or whatever took hold of me.

"I found out how children really blossomed when they did well in their music. Music allowed them to hold onto that sense of hope, just like it had in my own experience. It helped people to feel good about themselves, and once you have self-esteem, other good things become possible, both in school and in your personal life."

Dr. Turnbull explains that, historically, the great boys' choirs of the world have started off as schools. "But we had to start where we could start—with an interest in singing, with kids who could sing and wanted to sing." The school—officially chartered as The Choir Academy of Harlem in 1993—evolved as it became clear that an academic component was crucial to full development of the children.

Not surprisingly, under Dr. Turnbull's leadership, The Choir Academy is also a resounding success, as evidenced by the fact that 100 percent of its graduates continue on to college. Perhaps the rock-solid foundation on which Dr. Turnbull's philosophy rests accounts for this remarkable record.

"I have read all the papers and speeches about education and accountability and higher goals," he says, "and all of that is wonderful. But nobody is talking about the human aspect. How do you develop the human being? It's important not just to be smart but also to be a good person. Mediocrity abounds today, not just in quality of work but in spirit. To me that's a major issue."

In fact, says Dr. Turnbull, all the theorizing may do more harm than good. "Teaching is becoming more difficult in that there are too many rules and regulations, too many things teachers are required to do that have nothing to do with truly caring for students. This is what breeds mediocrity. Also, teachers are not paid enough, nor are they respected enough. If you consider that teachers spend more time with kids than their parents do, teachers should be paramount."

To this teacher extraordinaire, it's very simple: "Teaching is all about caring."

And for bureaucrats, administrators, desk-warmers and clock-watchers, Dr. Turnbull has some advice: "If it's just a job, then don't teach. You have to be really ready to make a difference. You need to be a shaper of human beings. Teaching is a sacred trust."

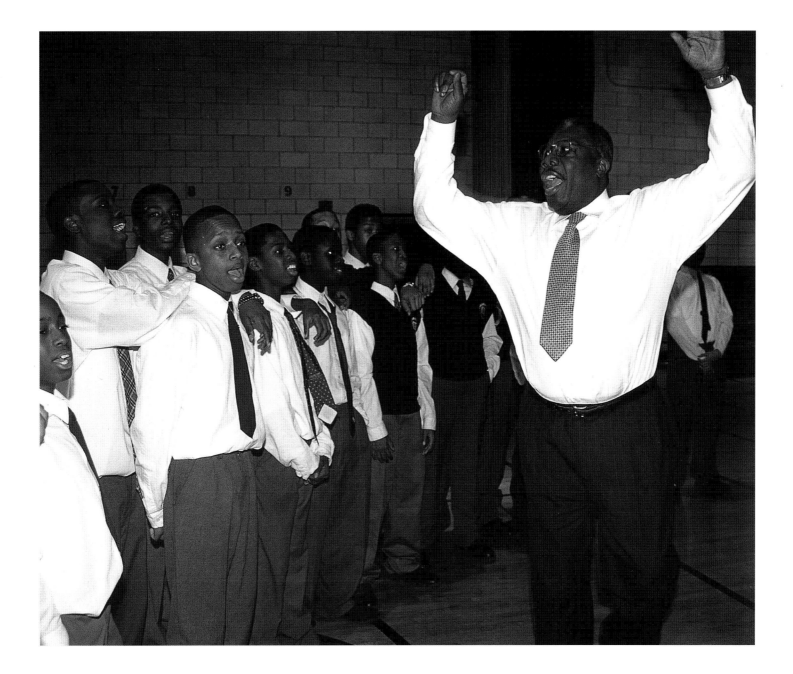

Eric Hoffman

Fourth and Fifth Grade Teacher, East York Elementary School
York, Pennsylvania

"An older teacher once advised me, 'Never smile until Christmas.' Well, that's just bull."

When he was in third grade, Eric Hoffman's teacher asked the students to draw a picture of what they wanted to be when they grew up. "I drew a picture of me at the desk with the book and all the kids in front of me."

Whether predestined or not, Hoffman did become a teacher. But he will tell you that there is still some question as to whether he has grown up or not—even after eleven years in the classroom at East York Elementary in York, Pennsylvania.

As he always points out to his twenty-three fourth-graders, "There are twenty-four kids in here, and I'm the tallest and I'm in charge."

That's the key, Hoffman says, to his classroom magic—being "tuned in" to the kids. "The first half hour every morning is our 'class meeting'—a time just to talk to each other, find out what we did last night. On Mondays, after the weekend, we'll 'review' any movies we saw. I tell them about my life as much as they talk about theirs. I just think it's really important to establish that rapport."

That rapport makes teaching possible but not inevitable. To keep his students interested and involved in the learning process, Hoffman taps his considerable resources of energy and creativity. "Yes, you have to be creative," he says, "in order to bring the information to them at their level, to really engage them."

For example, Hoffman recalls a recent discussion about how, after the Revolutionary War ended, the colonies quickly started fighting among themselves. "I gave the class a ten-minute break," he says. "I told them I had to take care of something else, and they could spend the time playing a game or whatever. They started quarreling immediately: 'We want to play this . . . no, let's do this.' There you go, I told them—you're just like the colonies after the king was gone."

Hoffman's method of teaching that lesson next time will most surely be different. "Good teaching is presenting lessons in dynamic ways," he says, "and not the same way every day. Some days I flop. Good teaching is admitting that and trying it again."

But, fundamentally, good teaching is staying tuned in, knowing your audience just as well as you know your material. "You have to be interested in what they're interested in," Hoffman says, "which means caring about them. Good teaching is being there for the kids. Once they know you are there for them, the rest is easy."

Debbie Scesa

Music Teacher, Farmland Elementary School
Rockville, Maryland

"I think the most important thing I can teach my kids is to think for themselves. If I'm not teaching that, I'm not doing my job."

You could say that Debbie Scesa had opera in her blood—not to mention her bones, eyes, ears, and every fiber of her being. As far back as she can remember, her extended Italian family would gather at her grandmother's house on major holidays and, while the women and children sat on the living room floor, the men in the family would sing whichever opera had been selected for the occasion.

"We would put on the old 78s, and the men, with their wine glasses still in their hands, would stand up

in their chairs and belt out the parts that had been assigned to them. It was interesting, to say the least," Scesa recalls.

Scesa abandoned opera in high school—"It wasn't cool"—but at Ithaca College she had a professor who rekindled her love for it. "He allowed me to believe that opera was legitimate," she says. "That someone my age could listen to it and love it."

By that time she was already planning to be a music teacher. Along with a love for opera, a deep respect for the teaching profession was part of her upbringing. "I was the first person from either side of my family who graduated from college," Scesa explains, "and it was somehow expected that I would become a teacher. Part of it was that my mom considered teaching such an important profession, and part of it was that it was the most accepted profession for girls of my generation. Lucky for me I loved it."

It was twenty years, though, before Scesa was able to bring together her love of teaching and her love of opera. Needless to say, opera is not part of the standard elementary school curriculum. But when Scesa found out about a program for school kids from the Metropolitan Opera Guild called "Creating Original Opera," she jumped on it. "The idea of my students forming their own in-school opera company was totally exciting to me."

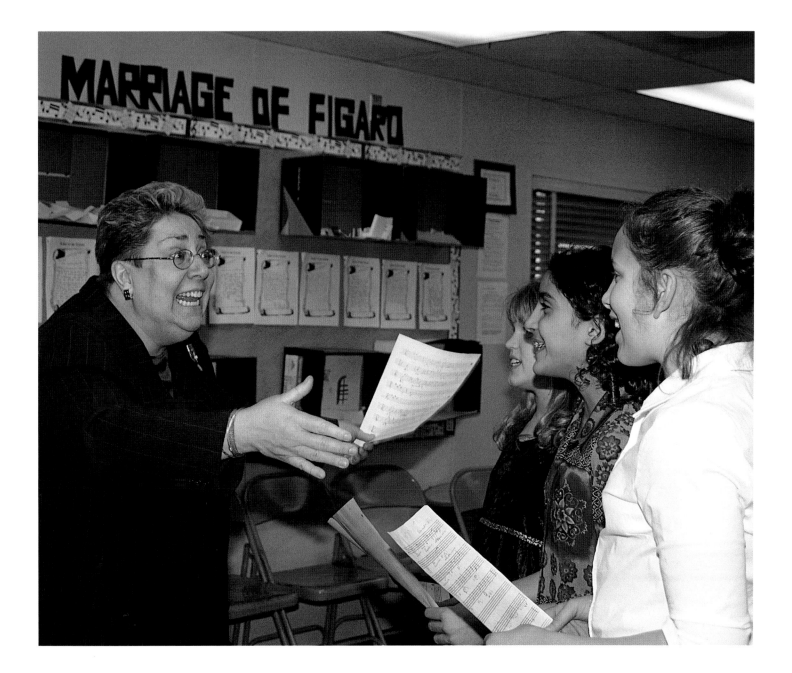

Scesa signed up for the program eight years ago, and as soon as she completed the initial training, she returned to her fifth-grade class and formed the company. The first order of business was for the class to come up with a name. "They wanted to be clever," says Scesa, "and they knew the program was unique. So there it was: La Clevique Kids Opera Company."

But "clever and unique" doesn't begin to tell the story because, as Scesa explains, the kids do everything. "We have a production manager, a stage manager, writers, composers, set designers, carpenters, electricians. . . . The kids actually build their own lights from scratch, using No. 10 cans and lamp holders. They build a dimmer board so they can raise and lower the lights. We have costume and make-up designers. All students."

How? Part of it is realizing that kids can do anything if they have the opportunity and the motivation, and part of it is Scesa's own gumption. "One of my mottoes is, 'If you don't ask, you don't get,' so I went to see Deborah Evans, the education director of the Washington Opera, and asked if we could become partners." The professional company agreed to the proposition, and the result, Scesa says, is that her class can now "shadow" a real opera company.

"We go to the Washington Opera House about ten times a year," Scesa says. "We do a wig and make-up class with Olson Associates, who does the wig and make-up there. We go to their costume warehouse and meet with their designer. We go backstage and meet with the production manager; we watch sets being built from scratch, which is exactly what our students do. Our PR team meets with their PR team. Not to mention getting to meet their composer, Carlisle Floyd, and Placido Domingo, who is now the artistic director there."

If this sounds like a program for prodigies destined for the Julliard School, Scesa is quick to correct that impression. "This is for every child," she declares. "It is not for gifted kids. We talk a lot about multiple intelligences, and because of all the different kinds of work involved, this program really hits all those different kinds of abilities."

Yet another virtue of the program is its interdisciplinary nature, which quickly won over dubious administrators. As Scesa puts it, "Over the years, I've tried them all, but this is the only program I've ever found that truly integrates the arts into the curriculum." At the same time, because every child has his or her task to do or role to play, the children are learning responsibility, too. "We are actually preparing kids for the real world," Scesa claims, "because they all have their own job to perform and they have to do it fairly independently."

But the real impact of the program, Scesa says, was highlighted when the children decided one year to write their opera on the theme of death. "A student had died in September," Scesa recalls, "and it was very much on the children's minds. Of course, there was an uproar—this was inappropriate material, etc.—but the

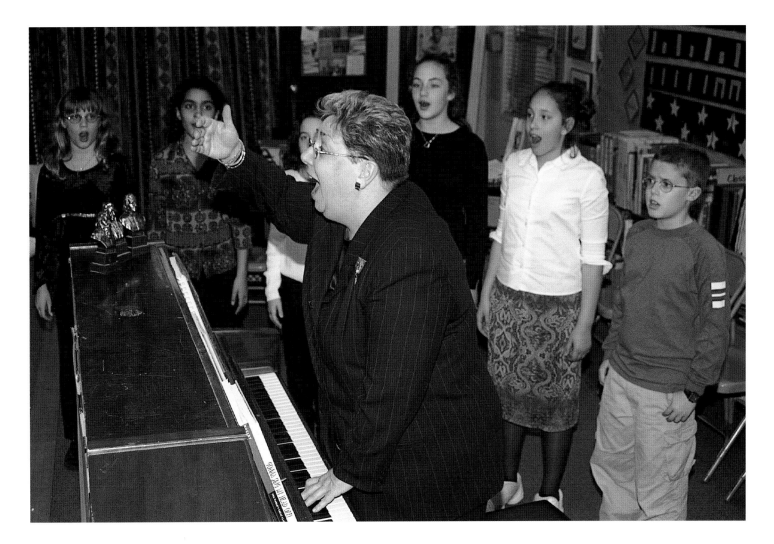

whole point is to let the kids express what they care about, what they feel deeply about. Ultimately the children prevailed, and it turned out that their opera was a catharsis for the whole community."

Whether her students go on to become opera stars—or even opera lovers—is not really the point, Scesa maintains. "What they will become, I hope, is better individuals because they've had to learn self-reliance and personal responsibility."

Lu Yi

Master Trainer, San Francisco School of Circus Arts
San Francisco, California

"Everything comes from the heart. I tell students, 'You want to do something, you must love it.'"

Lu Yi began acrobatics training in 1952 at the age of twelve. When he expressed an interest in joining a circus (which meant, in China, an elite troupe of gymnasts and acrobats), his parents were not pleased.

"My family know the circus very hard," Lu Yi says. "Very bitter. Very dangerous. My mom very worried."

Economic conditions in China in 1952 were difficult at best, he explains, and life as a circus performer would be particularly precarious. "Danger of not making a living, danger also of dying. Circus training double bitter. First, training very hard on body. Fall down. Hurt. Then, second bitter, teacher is hitting you. Teacher always hitting."

A half-century later, at the renowned San Francisco School of Circus Arts, Lu Yi still believes in rigorous training, but no hitting please. "Even in China I never hit," he says. "Very bad. I love my students."

Having performed in and directed circuses around the world—and survived a year of imprisonment during China's Cultural Revolution—Lu Yi was artistic director of the Nanjing Acrobatic Troupe at the time of his emigration to the United States in 1989.

After serving as director of New York's Big Apple Circus, he was lured to San Francisco by Judy Finelli, one of the original founders of the circus school there.

Now sixty-two years old, Lu Yi relishes his role as master trainer despite the inevitable frustrations. After all, the teenagers in his classes are not always prepared for the rigorous regimen that Lu Yi prescribes. "They have talent," he says, "but not time. In morning they will call, say 'I can't come today.'"

Lu Yi makes no secret of what will be demanded of his students. "Hard work," he tells them, "and you need to be very patient to become better. I very honest. Otherwise, waste of time."

But the deep satisfaction of watching dedicated students improve is the ultimate reward for this master. "I love teaching," he says. "Different students, different talents, but always, how to make them better?"

At the San Francisco School of Circus Arts, the globe-trotting Lu Yi has found a home, a highly regarded program, and students in which he takes a fierce and paternal pride: "No children in the United States, nowhere, can do acrobatics better than them," he beams.

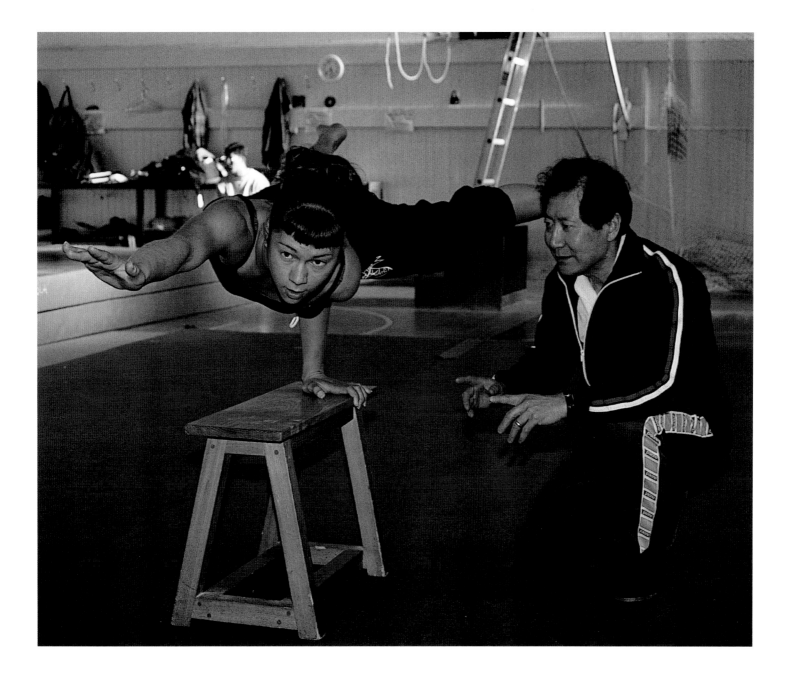

Rhonda Nachamkin

River Eves Elementary School
Roswell, Georgia

"If you teach your whole class like they are gifted students, they will all learn like gifted students. Children will rise to your expectations."

I wanted to become a teacher from the first moment I met Mrs. Butterworth, my kindergarten teacher," Rhonda Nachamkin says. "She was such a fabulous role model."

But if her kindergarten teacher inspired her to teach, it was Nachamkin's first-grade teacher who honed her style. "She was young and beautiful, but she was *so mean*. It made me want to take the opposite approach, and make all my children love me and want to be in my class."

After twenty-five years in the classroom that philosophy is still much in evidence. In the summer of 2000, Nachamkin became certified to teach in her school's new English Speakers to Other Languages program.

"It's a program to help meet the needs of the growing number of children here in Atlanta who enter school without the basics of our language," she explains. "Our job is to immerse them in English— listening, speaking, reading, writing, putting on plays and puppet shows, making videos—anything to help them explore our English language."

And at the same time, according to Nachamkin's credo, to make it fun.

"I do everything with a giant flair," she declares. "I use big props. My classroom becomes the land or place or event we are studying. If the children can live what they learn," she believes, "they'll remember it."

Nachamkin also believes that to make learning memorable and enjoyable, the good teacher must be bold enough to try something new "and just go with it."

Pickle Day, for example. "Having spent so many years going through the same routines during the month of December, I decided to invent a new holiday," she says. "We would celebrate the pickle. So we counted pickles, tasted pickles, wrote poetry about pickles and wrote letters to all the pickle companies." Pickle Day, now a huge annual event, officially arrives when the Cates pickle company inflates a giant pickle jar in front of the school.

Equally inventive is the classroom TV set, on which her students "produce" their own shows. Using dowels and surgical paper, the students write and illustrate stories and scroll them across the screen.

Clearly, Nachamkin has followed her own advice: "You've got to make learning fun and interactive. And follow your heart."

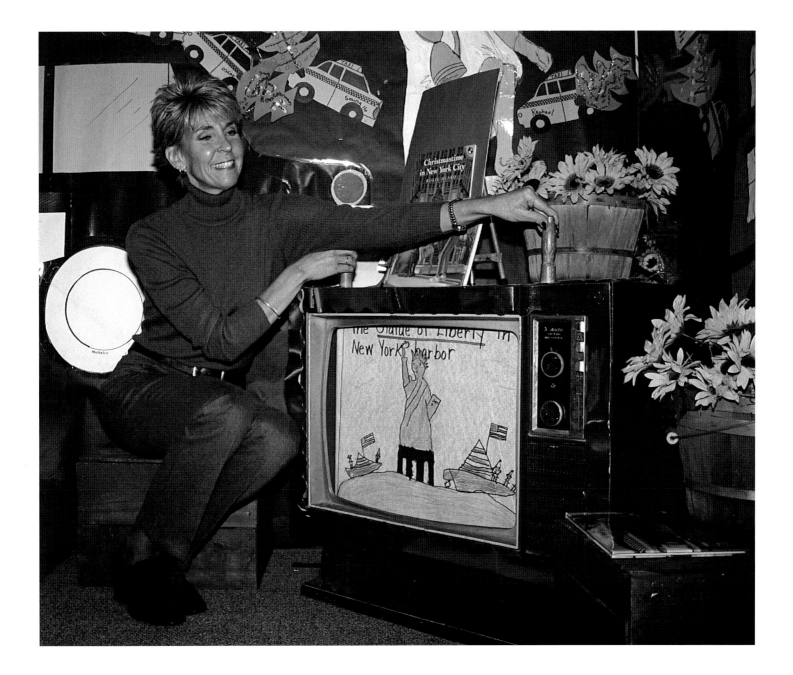

Myron Blosser

Science Teacher and Department Chairman, Harrisonburg High School
Harrisonburg, Virginia

"My father, who was extremely pro-education, always used to tell me, 'Don't let your homework get in the way of your education.'"

Myron Blosser's defining moment as a teacher occurred during his second year in the classroom. His students were finishing up their test on atoms and subatomic structure—electrons, protons, molecules, etc.—and as they handed in their papers he asked if anyone had any questions before they moved on to a new unit of study.

"Clint, one of my best students, full of energy, very precocious, raised his hand and said, 'Mr. Blosser, like, are there any atoms in this room?' At that moment I realized I had failed as a teacher. We had spent two weeks on this unit. I thought I had done a good job, but obviously the students had failed to make a practical application."

In the sixteen years since, "making a practical application" has been what Blosser's science classes have been all about.

In the summer of 1998 and again in 2000 Blosser led month-long "Coast to Coast" excursions, wherein he and a handful of faculty accompanied twenty-two students across the country in a full-size motor coach equipped with laptops, graphic calculators, and even a satellite system. "Our idea," he says, "is to make the United States our classroom and the national parks our laboratory."

On more than one occasion he has telephoned Nobel Prize-winning scientists from his classroom to have them help individual students solve problems that were puzzling them. The lesson is complete when the students then teach the rest of the class—and Blosser—what they've learned from the scientist.

For the past seven years, Blosser has held an annual biotechnology symposium on campus to which he invites leading scientists representing the cutting edge of this new discipline. Last year's was attended by 250 students from twenty different area high schools, and the program's highlight was an appearance by David Ayres, the geneticist in charge of the cloning of Dolly the sheep.

Blosser and his students have recently been sexing calf embryos with a local farmer. "We can take the DNA out of one cell of a calf's embryo, amplify it, and tell if the embryo is male or female. Since the farmer is interested in only female calves, this is a tremendous service for him."

All these experiences, all these opportunities,

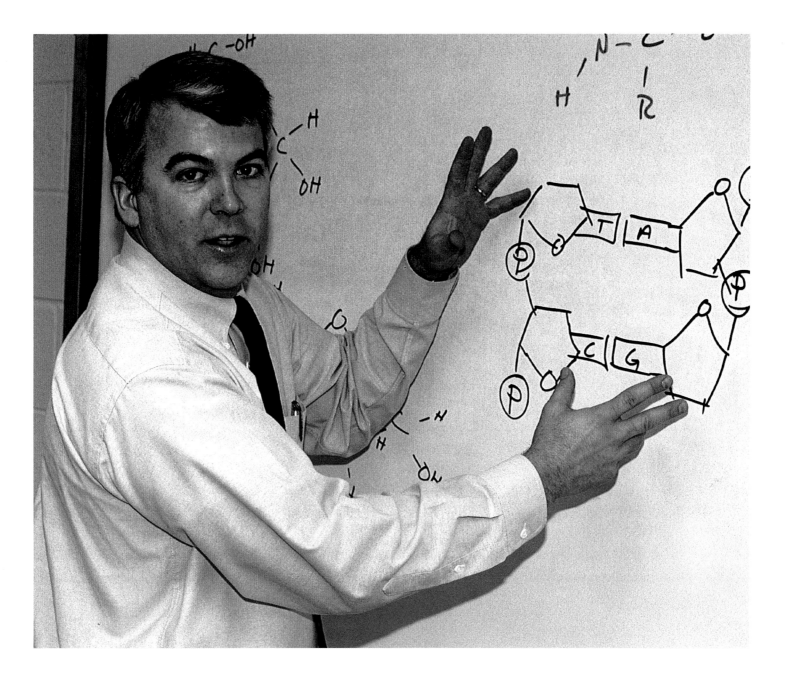

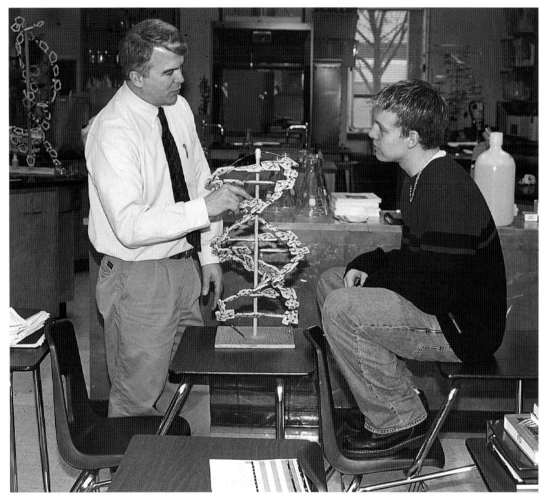

teaching brings the whole student to the learning process. To illustrate the impact of learning that involves both the head and the heart, he tells a simple anecdote: "I like to tell my students that I vividly remember what I had for dinner on December 27, 1987, as I sat in a little restaurant at St. Pete's Beach in Florida. Why do I remember? Because it was my honeymoon. On the other hand, I cannot honestly remember what I had for dinner two nights ago."

When you add emotion and experience to education, Blosser says, "Memory is suddenly not an issue. You *will* remember."

This determination to reflect a teaching philosophy that took root that day sixteen years ago. "My philosophy is that experiential education is the best kind," Blosser declares. "My goal is to make learning real and relevant, to take students out of the classroom."

Put another way, Blosser believes that good give his students experiences, Blosser says, is what guides his every step. "I like to break the walls of my classroom down," he says. "The confines of the classroom do not constitute real life, and so I'm always trying to take education into the community, into the larger world outside."

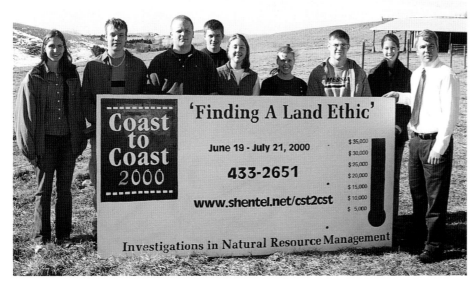

'Finding A Land Ethic'

Coast to Coast 2000

June 19 - July 21, 2000

433-2651

www.shentel.net/cst2cst

$ 35,000
$ 30,000
$ 25,000
$ 20,000
$ 15,000
$ 10,000
$ 5,000

Investigations in Natural Resource Management

Blosser admits that to achieve that goal by providing such a wide range of meaningful experience, a teacher has to be willing to take risks. "It seems that a lot of teachers lack that willingness," he says, "but risk-taking is something I thrive on, even though the possibility of failure is great." For example, in developing the first "Coast to Coast" program, Blosser suddenly faced the necessity of raising $40,000. "That's a lot of bake sales," he laughs. His solution was to get the community involved—the Kiwanis Club, the women's clubs, the newspaper, local TV—an idea that not only worked but confirmed his belief in taking education out of the classroom.

To new teachers entering the profession, Blosser would pass along this same "revelation" that his eighteen years in the classroom amply demonstrate:

"Teaching cannot be done in isolation. And the teacher who goes into his room and closes the door is really missing out on a tremendous opportunity. I believe in nothing so much as opening our doors, removing our walls, and making the school a part of the community."

Unfortunately, the task is not getting any easier. "In fact," says Blosser, "the number of experiences students bring with them to the classroom seems to be diminishing. As students become more computer literate, more knowledgeable on that level, they seem to have fewer experiences. They seem to be less in touch with their environment and their surroundings."

But those fortunate enough to end up in a science class taught by Myron Blosser—named by the National Association of Biology Teachers as 1998's Biology Teacher of the Year and the recipient in 1999 of *USA Today's* First Team Teacher Award—are going to have an experience. Most likely the experience of their lives.

Sally Fairchild

Family and Consumer Science Teacher, Metro High School
Cedar Rapids, Iowa

"If you show kids that you sincerely care about them, they'll try their best to learn for you."

Some students, university-bound, need to learn advanced writing skills. Others, headed down the information highway, need expertise in computer science. Still others, who for one reason or another have veered off the well-marked path, don't know where they are going. Their needs are different . . . and urgent.

Meet Sally Fairchild, who has spent the last sixteen years of her thirty-six-year teaching career at Metro High School in Cedar Rapids, Iowa. Metro's students are those for whom, as Fairchild explains, "conventional high school did not work out." It's a diverse group: "Some have been into drugs or alcohol; some have been sent to us by court-order; some have children and come here because we offer day care; some work full-time and need a flexible schedule; some are just highly intelligent and march to their own drummer."

"There are all kinds of needs," Fairchild says, and her job is to find ways to meet them. As a family and consumer science teacher, she offers classes in "gift shop," food planning and preparation, parenting, relationships—that is, fundamental life skills.

But more fundamental than those skills, she realizes, is the need for the kind of self-esteem that will, first, keep the kids in school, and, second, convince them of the value of the lessons they learn. And so it was that Fairchild, while writing a drop-out prevention grant, proposed the bizarre idea of creating a clown troupe.

The fact that Metro Clowns, now two years old, has more bookings than it can accommodate only begins to explain the venture's astounding success. A more important measurement is the range of skills that the students master eagerly: "They make their own outfits," Fairchild explains. "They write their own material. The troupe has to be self-sustaining, so they have to manage their budget. They control inventory. They design business cards and fliers on the computer. It's just amazing."

Most important of all, though, Fairchild says, is "the incredible self-worth that develops in the kids. After all, everybody loves a clown, and bringing happiness to other people just makes the kids feel wonderful."

What goes around comes around. For giving these troubled kids reason to feel good about themselves, Fairchild was named the Teacher of the Year by the National Association of Family and Consumer Science.

Marzet Farris

Industrial Arts/Applied Technology, Conackamack Middle School
Piscataway, New Jersey

"You have to teach the whole child. . . . It takes a lot of effort, it takes a lot of time. Sometimes it takes a lot of heartache."

Marzet Farris didn't go looking for the whole world. The whole world came to him. Born and raised in Piscataway, New Jersey, Farris graduated from Piscataway High School in 1960. During his senior year in college, he applied to teach at Piscataway's Conackamack Middle School which was just then being built. He became one of the school's original faculty members in the fall of 1964 and has been there ever since.

If that sounds like a story about a guy who just never wanted to leave home, there's more. Farris will tell you that he became an industrial arts teacher because building things was what he had always done. "That's what we did as young kids here in Piscataway. We built things—it didn't matter what. If you had some wagon wheels, you made a scooter. Whatever. So basically it wasn't so much my wanting to be a teacher, but rather just continuing on in a familiar environment."

To complete the picture, imagine Piscataway in the 1950s before major highways or subdivisions. "Mostly it was just farm country," Farris says. "For fun, we played in the woods. Brooks ran. Vines grew."

But suddenly the twentieth century arrived, to say nothing of the twenty-first. Today, Conackamack Middle School is a National School of Excellence serving a suburban community forty miles from New York City. Its approximately 500 students constitute a rich mix of cultures representing a long list of nationalities that include Barbados, Colombia, Nigeria, Guinea, Pakistan, India, Russia, Trinidad, Saudi Arabia, Korea . . . and more. As the school's literature proclaims, the "New America" of multicultural diversity that demographers see in the near future has already arrived at Conackamack Middle School.

The fact that Farris is still there—to say nothing of the many awards he has won—teaches an important lesson: some great teachers, as conventional wisdom holds, are born to the job, but others grow into it.

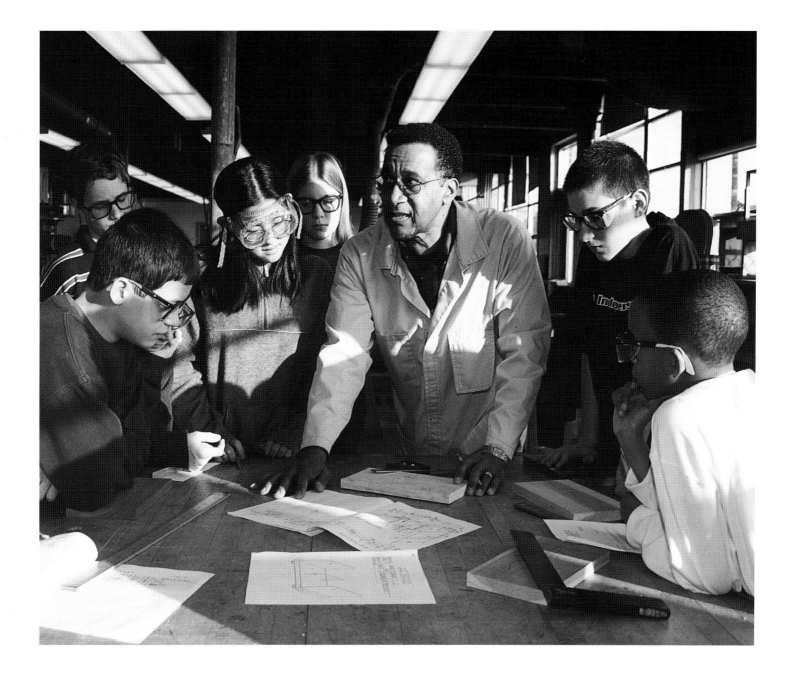

Today, the man who never left home would give this advice to newcomers to the profession: "Don't be afraid. Teaching means learning—learning to give, to share, to let go and not hold back. You have to be willing to give up something of yourself so that the students can grow and be empowered. Some teachers insist on the separation: I'm the teacher; you're the student. But I see them as just grown-ups, not teachers. I want my kids to know that I'm not afraid to go off the edge with them."

This belief in the concept of empowerment, of giving students a chance to assume control and responsibility, lies behind the development of Farris's renowned "Domino Fax to the Max" program. The program's origins were humble: a group of his students, "hanging around the room looking for something to

do," started pulling scraps of wood out of the scrap box and trying to stand the pieces on end to create a long domino line.

"At first," Farris recalls, "I was annoyed. Here were all these pieces of wood clattering all over the room. But these eighth-graders were so into it, so excited, it made me stop and think. And then the whole idea came to me. If I took this wood and cut it into uniform pieces [like oversized dominoes], then we could create a

whole unit—math, science, technology . . . time, measurements, perimeter, rhythm. There was no end to it."

But the most innovative aspect of the program, as it has evolved, is that students teach students; the eighth-graders teach the sixth-graders. It happens like this: Each spring, the seventh-graders nominate twenty students who will be next year's "Fax to the Max" facilitators. Each facilitator has a group of sixth-graders to whom he or she teaches geometric shapes. Each group chooses a shape, figures out how to create it using seventy "fax dominoes," then reproduces the shape on the classroom floor. The groups are judged on accuracy of the geometric shape, completion of the "domino effect," and speed of the resulting chain reaction.

At the end of the school year comes the "Domino Jamboree," at which each sixth-grade class designs a giant domino shape. These figures are arranged in a circle around a central design created by the eighth-grade facilitators, the object being for the chain reaction of each design to set off collapse of the next design, culminating in the fall of the dominoes in the center.

The "Fax to the Max" program, with its emphasis on student-directed learning, has been so successful that an entirely new program has evolved: Shakespeare Troupe. As Farris wryly explains, "A group of egotistical seventh-graders who couldn't get into the eighth grade "Fax to the Max" group decided they wanted something to do. They happened to be really interested in Shakespeare, so they came to me and asked if I would help them create a Shakespeare group. Now the eighth-graders—the Shakespeare Troupe—put on scenes of plays for the sixth-graders. And they train the group of seventh-graders who will take their place the next year. It has really taken off."

For the students, says Farris, these programs "are fun, empowering, and evidence that anything is possible." And for Farris himself, "The experience has been far beyond anything I imagined as a young man—the respect that I've gotten, the recognition, the honors. But more than all that is that every student has allowed me to become part of their life."

Farris's career at Conackamack also proves that if you are open to it, the world will find you. "It's been a great ride, and I don't see it ending any time soon. I'm fifty-eight years old and have more fire burning now than I did ten years ago."

Dawn Mill

Elementary School Teacher, Nye Elementary School
Nye, Montana

"One thing you can say about this kind of situation: there are definitely no politics to worry about."

You might think Dawn Mill should be counting her blessings. After all, how many elementary school teachers have only ten students? But when you consider that Mill is the one and only teacher in a one-room schoolhouse in rural Montana, and that those ten students represent every grade from first through sixth, it doesn't seem like such a picnic after all.

Actually, Mill does have one blessing that she can count right now—the fact that for the first time she doesn't have any kindergartners in the mix. "That really is nice," she says, "because they need all the basics and really take a lot of time." So how, exactly, does the roster break down? "I have three first-graders, two second-graders, one third-grader, one fourth-grader, two fifth-graders, and one sixth-grader."

If she did have a couple of kindergartners demanding their share of time, it's hard to imagine where a single extra minute might come from. "Sometimes I wonder about my sanity," Mill says, as she recapitulates her schedule. "I teach forty-nine different lessons a day—that's forty-nine lessons that have to be graded and returned the next day. I take graduate classes. I have a husband. Right now at home, our cows are calving."

Of course, being the only teacher—the only adult!—in the school adds a few interesting lines to the job description, too. "You don't just teach," explains Mill. "You clean the building, you order all the materials. You are the teacher, the superintendent, and sometimes the mom. You don't get any breaks; there are no prep periods. You're in charge of every recess, every P.E. class."

But then Mill finds a second blessing to count. "I'm fortunate here in that I do have a music teacher who comes in once a week. At my first job I also had to teach music."

Mill is not asking for anyone's sympathy. She loves her job, her kids, and the dreams they have. "They're going to be dancers," she says, "NASA scientists, archaeologists, even teachers."

And she loves her one-room schoolhouse in the ranchlands of Montana, where snow drifts from high mountains and trout play in the sparkling Stillwater River.

"It really is beautiful," Mill says, but then pauses lest her blessings become too numerous. "Except when the mountain lions come too close to the school."

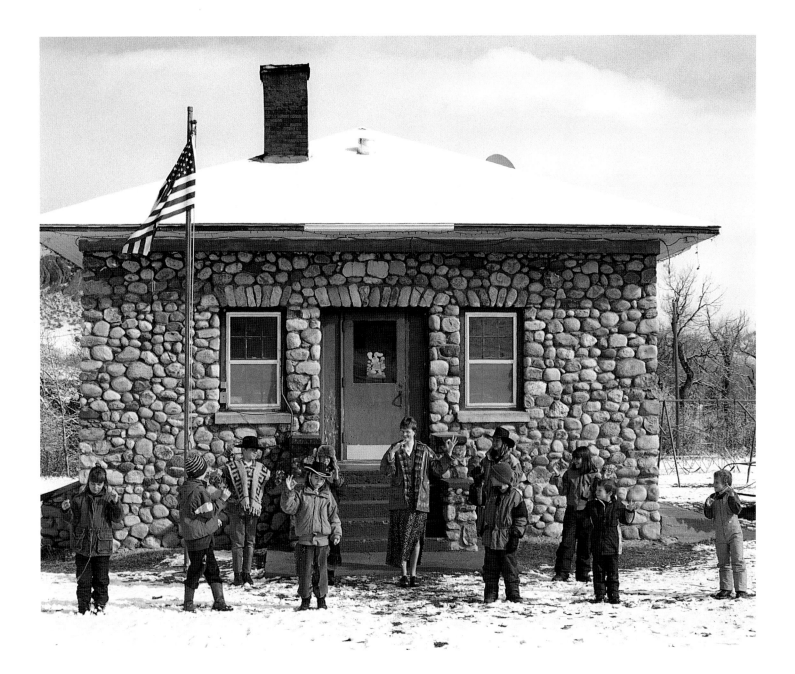

Mary Lara

Third Grade Teacher, De Miguel Elementary School
Flagstaff, Arizona

"I hope I'm not different from other teachers because all the teachers I know are totally committed to their students and committed to encouraging their students to become lifelong learners."

Maybe, as Hillary Rodham Clinton says, it takes a village to raise a child. Certainly, as Mary Lara has found out, it takes a village to move a telescope.

Two years ago, as Lara tells the story, a retired high school teacher and avid amateur astronomer by the name of Kenneth Walker was diagnosed with a terminal illness. Since no one in his family shared his passion, his granddaughter, a Flagstaff art teacher, took it upon herself to find homes for the two observatories he had in his backyard, ninety miles from Flagstaff.

As the sponsor of De Miguel's Astronomy Club, Lara heard soon enough through the teacher grapevine that a huge telescope could be hers for the taking, and she seized the opportunity. Her principal loved the idea of having an observatory at De Miguel, and so did the district supervisor—as long as he didn't have to give her any money. "You'll have to do it on your own," he told her.

"I had to get it all done with donations," says Lara. "The public safety department donated the special permit for transporting the observatory. They also loaned us a transport vehicle and an officer to escort us."

Meanwhile, back at De Miguel, a building had to be constructed to house the observatory, but, says Lara, "all the materials and labor for the building were also donated. The janitorial and service company that takes care of Flagstaff's public schools donated the money to have the architectural plans drawn up.

"It was really quite amazing," Lara says. "Almost nobody said no. So many people, so many small companies right here in little Flagstaff, Arizona, just jumped at the chance to make this happen for our kids."

Of course, the kids are the point, and the whole community agreed with Lara that the benefit to them would prove immeasurable. "It opens the whole world for them," says Lara. "It makes it all real. They realize that they can be real scientists, even in their elementary school. They can do real research. They are already partnering with professional astronomers in tracking variable stars. They are incredibly excited."

In other words, they are hooked, and Lara reiterates what all teachers know: "Then suddenly you're teaching them not just astronomy, but science and math and reading and writing. They are hooked on learning."

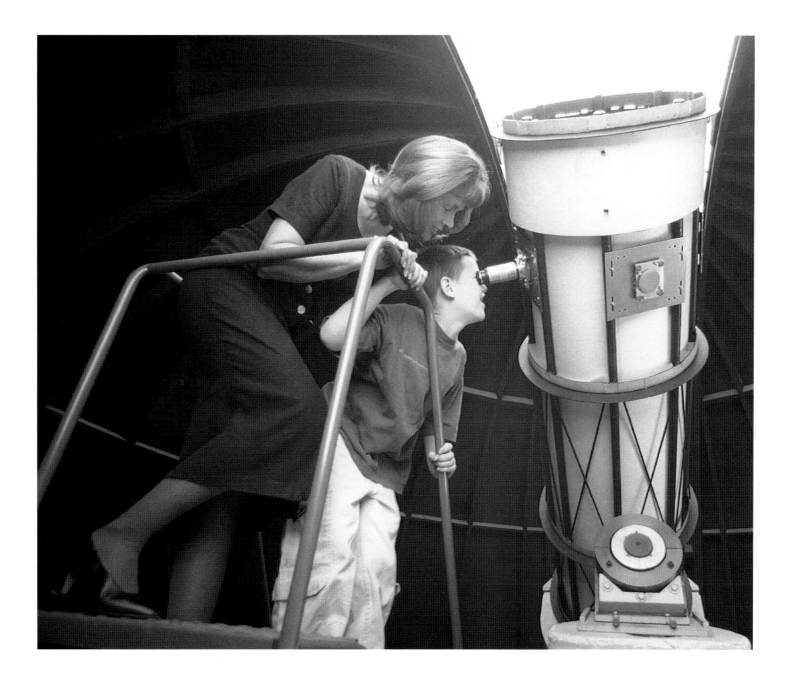

Michael Schmid

Art Teacher, Haverhill Elementary School
Fort Wayne, Indiana

"The artistic principles and the scientific principles are the same—observation, experimentation, creation."

Michael Schmid is not one of those people who knew from their first day in school that they were destined to be a teacher. Michael Schmid doesn't look back upon his own great teachers as his inspiration for entering the profession.

Fact is, Schmid never really cared for school—not because it was a struggle but because for the most part it was boring. "I was one of those students teachers hated," Schmid says, "because I really didn't have to do any work. I really didn't have to read the textbooks to get what the material was all about."

The exception was always art class. "Even through college," Schmid explains, "the art courses were the ones I enjoyed. I enjoyed making things. I enjoyed the creative process. But I was still a horrible student, and reading textbooks was one of those things I was never able to get into."

He figured that he would have to teach for the same reason that artists in every field so often do—to make a living while pursuing their "real" career. But when one of his advisors suggested that he work with elementary school kids, Schmid was aghast: "I told him I'd rather starve. I told him I would work only with high school kids who were already serious artists."

His elitism crashed and splintered on the hard pavement of the real world. "After two years of substitute teaching, the first real job I could get was in elementary art," Schmid says. Fortunately for him, and for the thousands of students whose lives he's touched over twenty-five years, he fell in love with it.

Two principles have shaped Schmid's teaching—and, in the process, have had a profound influence upon elementary arts education in the Fort Wayne area. These principles came together in the creation of the Foundation for Art and Music in Elementary

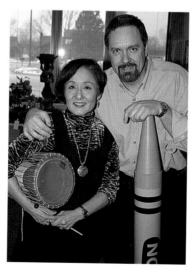

Education (FAME), a program that now draws more than 20,000 people to its annual children's arts festival in March.

The first principle is that art, as an expression of culture, is to be shared. Schmid and FAME cofounder Dorothy Kittaka had been promoting an Arts

Fest at the local school level for two years, but Schmid envisioned something larger, something that would be more culturally inclusive. "We are in an affluent community here in the immediate district," he explains, "but Fort Wayne is very mixed, with lots of minority students. I really wanted to share our cultures, to bring all these kids together in a noncompetitive environment."

With an emphasis on noncompetitive. "I think that's what helped generate such a positive response from all the teachers we contacted," Schmid says. "We made it clear that nobody was trying to outdo anybody. We just wanted to bring these kids together so that they could experience each other, see each other's art, share something of each other."

In fact, the principle of cultural sharing has become so integral to the program that it has taken on international proportions. The annual festival has featured appearances and performances by artists from China, Ireland, South America and Europe, and this kind of cultural exchange has become a key component. "Each year now we choose a different culture to promote and celebrate, and our whole year revolves around that theme. This year Russia will be our focus," Schmid says.

The other core tenet of Schmid's philosophy is that teachers should be actively involved in the community. Of course, that's what FAME is all about, he insists—getting art out of the classroom and into the community. But FAME is by no means Schmid's only interest. "Teachers are very fortunate to have the summers off, more or less," he says, "but you're not going to find me sitting by the pool drinking Mai Tais. My feeling is that if I have the time, then I should be out making things happen. I really like seeing things happen in the community."

Among the many programs that Schmid has been involved in, he considers one of the most rewarding his role in helping to establish Camp Watcha-Wanna-Do ten years ago. A week-long summer camp for kids with cancer, his work there, he says, has made him realize how fragile life is, and that life is not a spectator sport—an insight that Schmid, in turn, tries hard to pass along to his students.

"Things don't just happen," he says, "despite the impression you get from television, where a whole lifetime can go by in thirty minutes. You've got to work hard, you've got to experience things, you've got to get totally immersed."

In the final analysis, Schmid is less interested in seeing his students become another Wyland or another Calder—artists whom he especially admires—than in seeing them become positive members of the community, the whole community. "I'd love my students to develop a philosophy of compassion," he says, "of understanding and acceptance of people who are different, and of community service."

Dorothy Kometani Kittaka

Music Teacher, Haverhill Elementary School
Fort Wayne, Indiana

"You'd better come to teach with a positive attitude because the children can read you completely."

Unlike Michael Schmid, with whom she cofounded the Foundation for Art and Music in Elementary Education (FAME), Dorothy Kometani Kittaka readily credits her own teachers with shaping the life she enjoys today. All along the way—grammar school, high school, and college—teachers encouraged and inspired her, she says.

As a result, her choice of profession was not difficult: "I knew from my own experience that teaching really touched people's lives and made such a difference. I just felt it was the most important profession in the world."

But even before teachers began to touch her life, music had already captivated Kittaka's soul. "My earliest recollection of musical sound," she recalls, "was when I was four years old, behind barbed-wire fences in Heart Mountain, Wyoming, where my family was incarcerated for three years along with 120,000 other Japanese Americans during World War II. I can still hear the sound of the lone trumpet player, who played the same melody over and over each day in lament of his condition in those dark times." Kittaka says that hearing the melancholy tune of the "poo pah poo man," as he was called by all the camp residents, lifted her spirits and became the deep wellspring of her love of music.

To convey this love, and to bear witness to how music can transform people's lives, says Kittaka, was the real reason she became a teacher. Her own life is a case in point. She describes herself as a shy, insecure child who hid behind her mother when strangers appeared—except, that is, when she slipped out of the nursery school, and disobeyed her mother, to hear the music of the trumpet player. And later, she says, "hearing my first music teacher in a one-room schoolhouse in second grade convinced me that I had to take piano lessons and become the greatest pianist in the world." Although she is "by no means the greatest pianist in the world," Kittaka's point is that "without the arts, I might still be that quiet wallflower who needed to be asked to participate."

Kittaka's creed is simple: "The arts are what make us human. Time and time again we have seen a metamorphosis in children when they participate in the arts." Of course, most children will not become professional musicians or actors or artists, but to have such experiences in their early education, says Kittaka, will boost their confidence, their creativity,

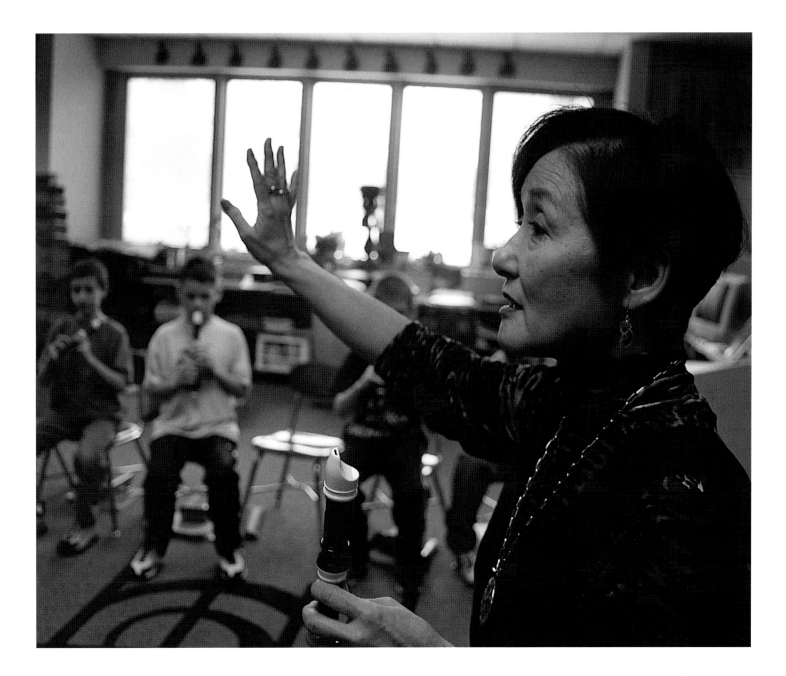

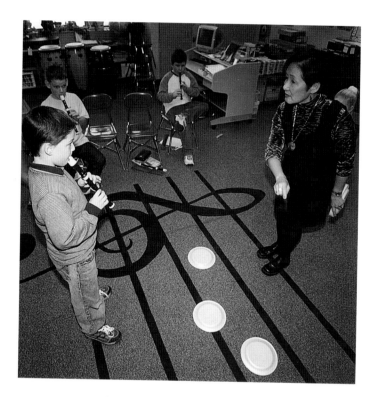

and the lifelong skills that will make a difference forever.

And if the power of the arts is such that it crosses cultural boundaries and links the human spirit, then teaching, says Kittaka, is indeed the most critical profession of all. "We can influence the course of the future by how well we make connections with students and their love of learning."

For thirty years Kittaka has been teaching music—and touching her students' lives—but certainly her influence has been most widely felt during the past fourteen years, as FAME has grown and evolved into one of the most remarkable children's art programs in the country. Schmid handed over the reins after eight years, and Kittaka has been president of the organization ever since.

Now a year-round celebration of the arts, FAME's justly famous programs include:

Fusion of Concert Colors–students listen to works performed by the Fort Wayne Philharmonic Orchestra, study their historical relevance, and then create their own artworks inspired by the music, which are then displayed in the city's Museum of Art.

Visiting Artists Program–brings internationally renowned artists into the classroom from a variety of artistic disciplines.

Composition Project–select students have the opportunity to work with FAME's composer in residence, David Crowe, to write and orchestrate an original piece of music which is subsequently performed by the Fort Wayne Philharmonic.

FAME Festival of the Arts–the annual two-day festival of children's art, music, dance and theater which began it all, and which now has expanded to three separate festival sites across northern Indiana.

FAME Summer Arts Camp–a week-long arts camp for boys and girls every July focusing on art, dance, music, creative writing, and drama, and also including outdoor recreational activities.

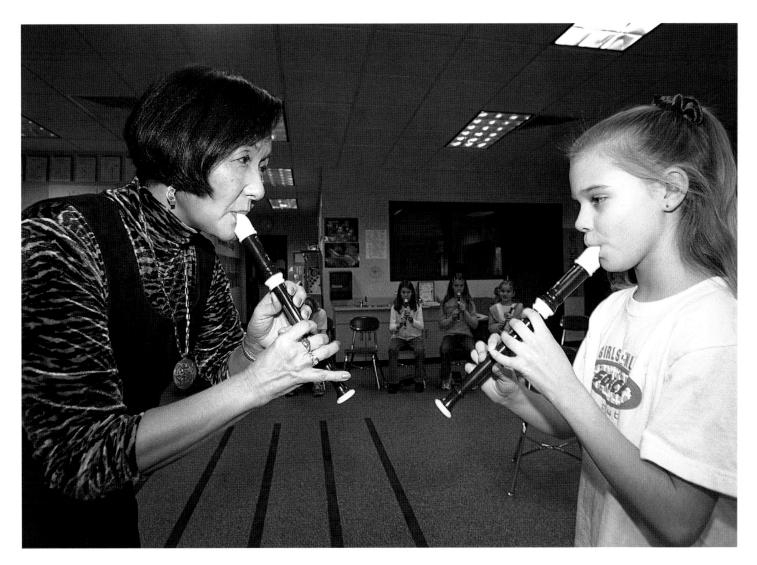

"We are offering the experience," says Kittaka. "We are saying to the children, 'You can be a composer if you want to. You can make up your own music. You can take a risk.'"

But it's enough if children simply "take something positive" from the experience. "What we are doing is not just teaching children music and art, but teaching them how to live with each other in this world."

Nancy Barnett

Special Education Teacher, Southside High School
Muncie, Indiana

"Our job is to build viable, contributing members of the community. We'll try to do whatever it takes."

After fifteen years on the job, Nancy Barnett was, in her words, "very close to burnout." The enthusiasm was gone. "I had been doing the same thing the same way for some time," she explains, "and things didn't seem to be working for me. It was very rough."

Some people would have quit and found a new career. Barnett simply reinvented the one she already had.

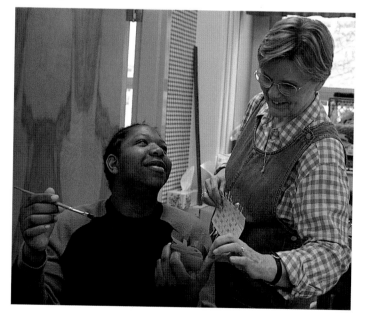

"I had $5,000 that my mother had given me," she recalls, "and I used it to explore an idea I had—a concept for a hands-on-type program for our special needs kids. I took the idea to my supervisor and she supported it, so then we had to take it to the state level. The state director of special education gave it the okay and underwrote my salary for the first couple of years using grant money."

That was in 1995, and in August of 1996 the "I CAN" Gift Shop, located in Barnett's classroom at Southside High School, opened for business. At the same time, Barnett's innovative and award-winning "I CAN" Program was officially launched.

In essence, the program is a small business—the gift shop—operated by the special needs students. The kids hand-craft the gift items—like paperweights, stationery, tea towels, placemats. They market and sell them, keep the financial records, and manage the inventory. "All the things you would have to do if you owned your own business," Barnett explains. And the items are "high end," she is quick to add. "When people come in here and see the stuff the kids are doing, they can't believe it."

At the same time, of course, the students are

mastering academic disciplines. "They're learning math concepts," Barnett says. "They're learning science, communication skills and industrial arts. It integrates all the parts of their normal curriculum." This is not to mention such fundamental "life skills"

as teamwork, responsibility, on-the-job behavior, and most important of all, self-esteem.

Everything about the program is intended to reinforce the students' belief in their own capabilities—beginning with its name, which, Barnett says,

was not hard to come up with. "For years, even before I started the program, I would make and cut out 'I CAN' signs and plaster them all over the walls of my classroom. So the name was already there before the program was."

But learning new skills, tackling new problems, creating product lines, working together successfully, taking care of business—these accomplishments only begin to tell the story of what the kids get out of the program.

As Barnett explains, the program uses grant money to buy the raw materials from which students craft the products they sell in the store. That means that sales produce real profit, net profit, and, Barnett says, "the students decide how to put those profits to use in ways that benefit the community."

Given the opportunity, their generosity is boundless. They fill laundry baskets with homemade housewarming gifts and deliver them to new Habitat for Humanity homeowners. They make quilts for babies who are suffering from AIDS. They fix sack lunches for the homeless. They create "handicapped awareness" programs and present them in the community.

Here is the ultimate benefit of "I CAN." "These kids have always been on the receiving end of everyone else's giving." Barnett explains. "They've never been allowed or permitted to give. But now, when they are the ones doing the giving, you see a completely different kind of person evolving. That's really the cornerstone of the whole program—to give."

It's clearly a win-win-win situation. The students experience the joy of giving, the pride of having something valuable to give; those in need enjoy the immediate benefit of the students' generosity; and finally, the community as a whole benefits from its reawakened appreciation of a part of humanity that might have otherwise been ignored.

When the Council for Exceptional Children named Barnett its Teacher of the Year for 2000, she welcomed the recognition as an opportunity to spread the word, to broadcast her message that "there are alternatives to book work for kids with special needs."

Needless to say, Barnett's program is being looked at, admired, and copied across the nation. Some start-ups are even co-opting the "I CAN" name, a prospect which does not bother Barnett in the least. "We don't care," she declares. "We don't need to have any acclaim at all. If the program is working, that's all that matters."

In the meantime, special needs students everywhere can rejoice in the fact that Barnett's enthusiasm has been restored. "Have you ever noticed how school smells on Monday morning?" she asks. "I just love coming in on Mondays and smelling the hallways."

Master Jun Lee

Tae Kwon-Do Master, Black Belt World
Raleigh, North Carolina

"Teaching is my way of life, and this is what I love to do. I don't think I will change my profession."

It's probably safe to assume that when Raleigh, North Carolina, proclaimed December 2, 1997, Master Jun Lee Day and presented him with a key to the city, Master Jun Lee became the only Tae Kwon-Do instructor ever to have been so honored anywhere in the U.S.

It's also safe to assume that the city was not merely congratulating him for earning his 7th degree black belt earlier that year, or for his ten years at the helm of Raleigh's Black Belt World, the Tae Kwon-Do school he established in 1986, or even for the international Tae Kwon-Do competition that he brings to the Raleigh Civic Center every year. The fact is that Master Lee was honored for "outstanding leadership and community service," and for exemplifying the stellar human qualities that he has always made a part of his school's curriculum.

In 1990, when he broke 5,000 boards in seven hours to set a new world board-breaking record, Master Lee was much less interested in personal recognition than he was in the thousands of dollars the feat raised for the Muscular Dystrophy Association. The other demonstrations he puts on throughout the year contribute money to his school's nonprofit arm, which in turn donates at least $5,000 a year to college scholarships for his students.

Master Lee's staunch values come from the simple farm life he knew as a boy in Korea, from a wise father who led by quiet example, and from his deep appreciation of the moral and spiritual foundations on which Tae Kwon-Do rests.

"The first thing I teach my students is manners and attitude," he says, ". . . morality, respect, and discipline are the foundation of my program." His ten-point teaching philosophy includes such time-honored principles as loyalty to family, fidelity to friends, respect for elders, care for all living things, and the affirmation that Tae Kwon-Do is to be used for beneficial purposes only.

When his students have moved beyond the popular image of "kicking and punching" to an acceptance of spiritual framework, says Master Lee, "then they are ready to learn the physical technique."

For both student and master, Tae Kwon-Do demands the letting-go of the self that Westerners find intriguing—but difficult. To teach or to learn this 2,000-year-old art, says Master Lee, "you must empty yourself, you must be humble, you must become like a newborn baby."

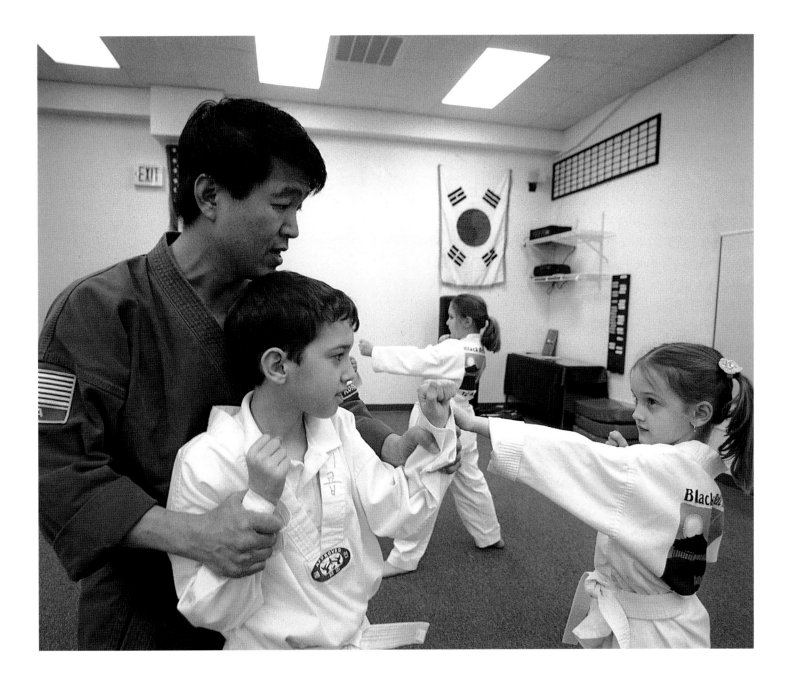

Becky Winters

Math Teacher, Central Middle School
Edmond, Oklahoma

"**Without teachers, there are no doctors, no lawyers, no presidents. I am responsible for the world, and I take that very seriously.**"

Becky Winters has not only arrived happily in Mathtropolis; she has overcome Mathphobia along the way.

"Honestly, it began with a fear of mathematics," Winters says. "I was a poor math student in high school." That might have been where it ended, as well, except for the "epiphany" Winters says she experienced while attending her younger brother's college graduation. "I was watching him walk across the stage when it hit me: I have to be a teacher."

Problem was, becoming a teacher meant returning to college and taking core courses, including math. "Of course, I failed the placement test for college math, and then I failed the placement test for precollege math," recalls Winters—which meant taking high school math all over again. "I was like, 'This is awful—I'm really terrible at math,' but then I had this wonderful teacher who explained it clearly, and all of a sudden . . . it was easy."

Winters made an A, and then another A, in college math courses, and in short order she had decided that she didn't want to be a reading teacher after all. If she could learn math, then she could teach it—"even to students who don't think they're very good at it."

But Winters's journey to Mathtropolis was far from over. "At first my teaching was totally traditional—sitting at the overhead writing problems, the students at their desks working problems, all of us watching the clock and thinking the forty-five-minute period would never end," she says. "One day it hit me. I went home and didn't sleep all night. The next day I went in, and we started brand-new. We closed the books and started thinking about what math is all about."

And the bright lights of Mathtropolis appeared over the horizon.

"Application, application, application," says Winters. "That's what makes math interesting and fun to learn." So within the boundaries of Mathtropolis—of which Winters is mayor—the students travel to locations like Algebra Airport (because the way planes land and take off is a true linear equation), or to Geometry Gardens (because geometry is all about symmetry, form, and relationships).

Along the way, Winters has turned the classroom over to the students. "I've tried to make them see that math is not a problem; it's a way for them to solve problems."

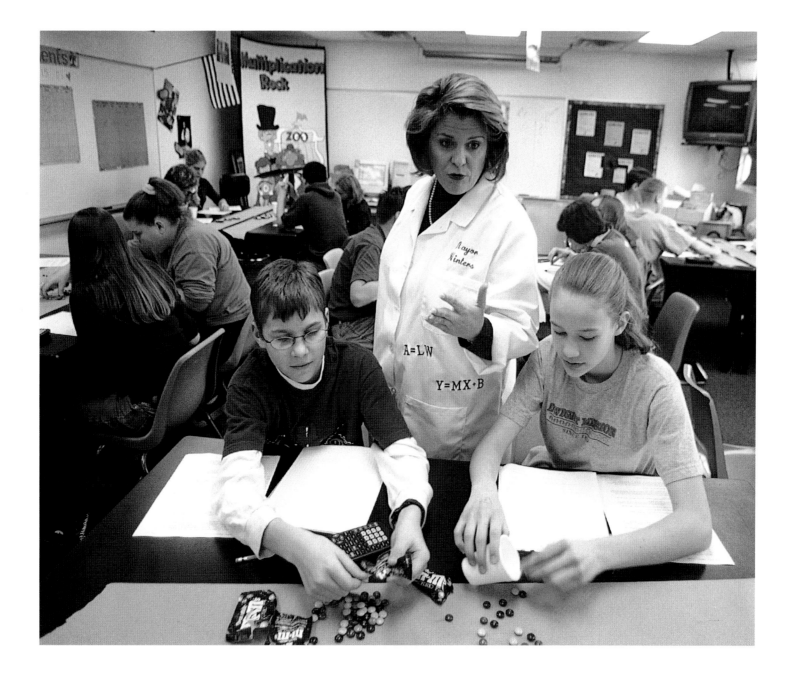

Norman Conard

Social Studies Teacher, Uniontown High School
Uniontown, Kansas

"Our classroom motto is 'He who changes one person changes the world entire.'"

Norman Conard is on a mission: to bring the whole rainbow-colored, multicultural world to a small conservative corner of rural Kansas.

"You have to understand," Conard says, "this is a very rural Kansas community. We have no African American students in our high school, no Jewish students; we are 98 percent Caucasian. So what we are doing is unique."

What Conard does—or rather, what his students do—is produce historical video documentaries, exhibits, and sometimes even performances that bring

to life fascinating stories that are uncovered during their research. Whether the subject is the famous bluesman Leadbelly, photographer Gordon Parks, or the Chinese laborers who worked on the transcontinental railroad, the projects generally focus on figures from America's minority populations.

"We're teaching diversity," Conard says, "and we're teaching tolerance here in rural Kansas. We're also telling great stories that teach multicultural lessons. Our students not only learn tolerance, but they pass the message on to their classmates and peers."

Conard emphasizes that a project has to begin with a great story because that's what generates excitement. "One of my ninth-graders," Conard explains, "decided to do a film on the transcontinental railroad. Okay. Nice topic. But not terribly exciting unless you happen to really be into railroads. But as he got into it, he decided to focus on the Chinese people who worked on the railroad, and now he's working with a woman at the San Francisco Historical Society who has put him in touch with a descendant of one of the Chinese bosses on the railroad. Now he's got a story and, in turn, he has taught everybody here so much about the incredible contribution the Chinese

It was one of these searches, Conard says, that put one of his students in touch with a man in Montgomery, Alabama, named R. J. Nesbitt. And who is R. J. Nesbitt?

"This was fantastic," Conard says. "R. J. Nesbitt, who is now ninety-two years old, is the man who drove over to Atlanta and convinced Martin Luther King Jr. to take the job of pastor at Dexter Avenue Baptist Church. So last year our kids went to Montgomery and spent two days making a film about this man who really helped shape the history of the civil rights movement."

made to that particular aspect of our history."

In their effort to "extend the boundaries of the classroom," Conard and his students do a lot of traveling on the Internet. "The students have learned how to find historical sites on the Web," Conard says. "Then they e-mail people who work at these sites and they use those contacts to touch real life."

Then there's the story of Elizabeth Eckford, one of the nine students who integrated Little Rock, Arkansas's Central High School in 1957. "One of our students saw the famous picture of Elizabeth being taunted on the first day of school and was inspired to make a film about her. She went to Little Rock, looked Elizabeth up in the phone book, called and said, 'I'm a

student from Kansas and I'd like to talk to you.' Elizabeth just loved our student and invited her to come retrace her steps on that day in 1957.

"The irony," Conard continues, "is that until that time Elizabeth had been in seclusion and refused all public appearances. But the documentary caused her to be reunited with a white student who had befriended her forty years earlier. Their reunion took place in Washington and was covered by CNN and other news media, and to this day Elizabeth Eckford credits our student's video project with changing her life."

Conard takes little credit. He says that finding exciting projects for his students to work on "is the key to everything we do here."

One of the most exciting projects currently under way tells the story of Irena Sendler, a gentile woman who rescued Jewish children from the infamous Warsaw Ghetto during World War II. "Some of our students discovered this story a year and a half ago—about this woman who smuggled 2,500 children out of Warsaw and found Polish homes for them. A story of unbelievable courage. She would list the names of the children and then bury the lists in jars in her garden so that later she would be able to tell the children their real identities. Our students developed a performance based on this story, 'Life in a Jar,' and they've presented it not only locally but as far away as New York City."

Even more remarkable, the students discovered that Irena Sendler is still alive today and living in poverty in Poland. Their performances have become benefits to raise money for Sendler, and they are planning a visit to Poland to meet and interview her. One of the highlights of the trip, Conard says, will be meeting a woman who was five months old when Sendler rescued her—"put her in a little box in a wagon, covered it over with bricks, and rolled the wagon past the German guards."

Honors have come Conard's way—Kansas Teacher of the Year, National Educator Award, National Social Studies Teacher of the Year—but this is one teacher who is in it solely for the students.

"When I get here at six-thirty in the morning, before all the other teachers, there are almost always two or three students waiting to get in, waiting to get to work on their projects," Conard says. "And at the end of the day I have to insist that they leave. They will keep at it until they are made to go home."

And if that's not sufficient reward, there are the little notes he finds scrawled on homework sheets from students working on the Irena Sendler project. "I'm changing the world," they might say, or, "Irena made a difference, and so can I."

Michael Randall

Language Arts Teacher, Martin Luther King Jr. Elementary School
Newark, New Jersey

"I think what makes me different from other teachers is my tremendous desire to learn. And whatever I learn, I love to teach."

Given the problems endemic to the teaching profession—low pay, long hours, bureaucratic intrusion, lack of support, indifferent parents, surly if not hostile students, and sometimes even physical danger—it seems remarkable that anyone would become a teacher.

More remarkable still, some people not only buck the odds, they pursue their chosen career in a manner so compelling and so uplifting that they inspire their students to become teachers.

Thus, in a profession so beleaguered and maligned, the torch of excellence is passed from one generation to the next.

Michael Randall was born between Brooklyn and Manhattan in a place he calls Welfare Island; his mother, as the place name implies, on welfare; his father unknown. In sixth grade, he was temporarily expelled from school for wielding a chair ("self-defense," Randall insists to this day) against an enraged teacher. He repeated seventh grade because, as he remembers, "I didn't know anything and I didn't have a handle on anything."

Then he met Mr. Flannery, a Spanish teacher who directed the after-school physical fitness programs. "If it wasn't for Mr. Flannery," Randall says, "the street life and the gang life would have been my life."

What Randall learned from Mr. Flannery was that fundamental cornerstone upon which all success is built: self-esteem. Thanks to the example—and the challenge—set by Mr. Flannery, by the end of middle school Randall had transformed himself into a student leader and top-flight athlete who would win a full scholarship to the University of Nebraska. Where he studied to become . . . a teacher.

In his language arts program at Newark's Martin Luther King Jr. Elementary School, Randall keeps his focus squarely on that fundamental lesson: "The key to it all is self-esteem."

That's why he often comes to school in traditional African clothing. During work towards his masters degree, he says, he studied the psychology of being African in America and the loss of sense of self that is often part of that experience. "How do you have self-esteem if you don't know who you are?" Randall asks. "Black children have grown up with this problem, so

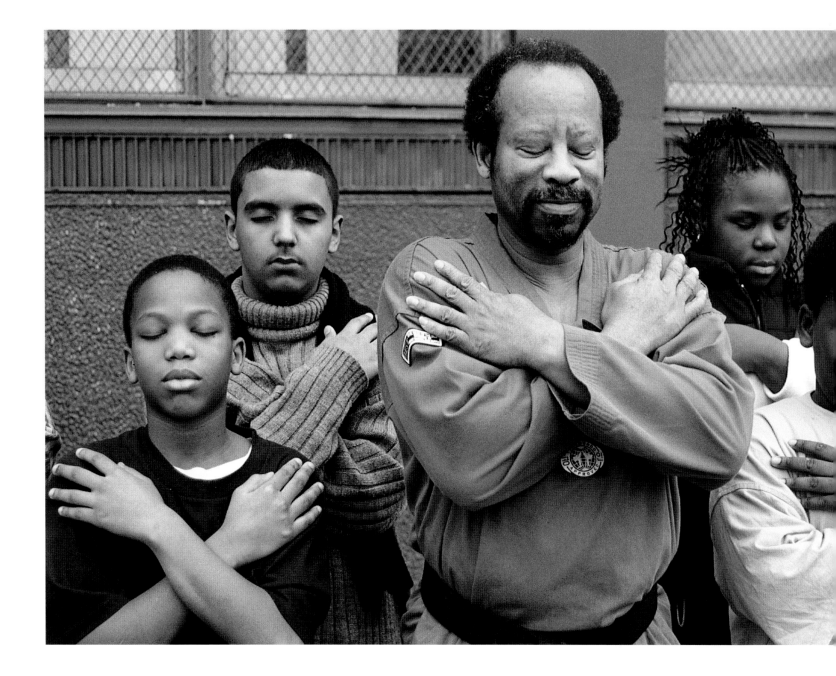

I am always trying to say, 'Know who you are and be proud of who you are.' Dressing like this helps me get that message across; it has an impact on them."

That's why he employs a multitude of teaching techniques, immersing his students in everything from music and singing to producing their own newsletter to practicing Tae Kwon-Do. "Even when I was a student teacher," Randall says, "I learned very quickly that everyone learns differently. And the more I expanded my ways to approach them, the more I captured my students' imaginations. I realized I needed to touch people's backgrounds, to give them a sense of where they came from, to get them really involved."

That's why he loves his computer lab, where even first-graders can work at their own computer terminal. The wonderful thing about the computer, Randall explains, is that it gives students the chance to go over material again and again on their own. "If you're not getting something," he says, "and I have to stand up there and say it again and again, you're not

going to feel good about that. But on the computer you can go over it until you get it, and nobody's going to be saying, 'You're dumb' or 'Why are you so stupid?'"

In fact, Randall singles out this aspect of computer-assisted learning as a particularly important aspect of the technology revolution: "By allowing students to work out problems for themselves, computers enhance their self-esteem and ultimately give them empowerment—and that's the most incredible thing you can give anybody."

What advice does this twenty-eight-year classroom veteran have for young teachers just starting out? "Find the best teacher in your school and make that person your mentor," Randall says.

Learn from the best in order to become the best. After all, everything is at stake. Here are the closing lines from Randall's poem, "Now That I'm Teaching"—

But most of all,
I remember
and I still see
God shining brilliantly
in the hearts of teachers who raise children
from the dead

Tierney Cahill

Sixth Grade Teacher, Sarah Winnemucca Elementary School
Reno, Nevada

"We don't know all the answers, but if we are open and caring and loving, then we can get beyond a lot of the difficult issues that teachers and students have."

It's hardly surprising that Tierney Cahill had every intention of becoming a civil rights lawyer. Beside her grandparents' mantel hung a portrait of President John F. Kennedy, over his famous quote: "Ask not what your country can do for you. Ask what you can do for your country." Her parents passed out McGovern buttons on the campus of Cal State Sacramento. It was that kind of household.

But while she was in the process of deciding where to go to law school, a college professor took her aside: "He explained to me that being a civil rights attorney was fine, but that if I really wanted to make a difference, by becoming a teacher I could show thirty children every year how to respect diversity and diffuse hatred. He doubted seriously that I could have that kind of impact as an attorney."

Ten years later Cahill is an elementary school teacher making a significant impact, thanks at least in part to her inherited thirst for public service and grassroots activism. When one of her students complained that in our political system today a person had to be a millionaire to run for office, Cahill disagreed.

"I got on my soap box and declared that anybody could run for office," she recalls, "and that's when the dare came: why don't you run for office, they wanted to know."

The idea was ludicrous, Cahill says—she was a single mom, with three children to raise and a job to do. "But when you look out into a sea of children and they're looking up at you with great big eyes, wanting you to step up to the plate . . ."

Okay. If the children would help her, Cahill would run in the upcoming election for the U.S. House of Representatives. As it happened, she won the Democratic party's nomination (in a Republican district), ran against the heavily favored incumbent, and polled 34 percent of the vote.

It's hard to call that a loss. "The system won," Cahill says, "because we proved that, really, anybody can run for office."

And, of course, the kids were the big winners. They campaigned, wrote speeches, designed posters and t-shirts, and, on election night, cheered and laughed and cried. They had experienced the political process.

"It was just one of those perfect learning moments," Cahill says with obvious pride.

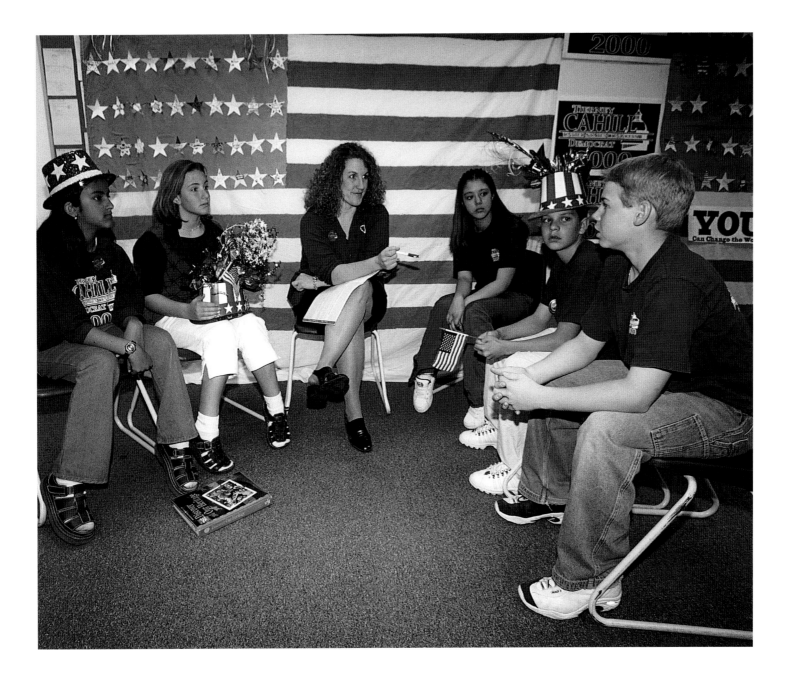

Andy Baumgartner

Kindergarten Teacher, A. Brian Merry Elementary School
Augusta, Georgia

"Classes should be an adventure every day. They should be places where children discover, where failure is kept at bay."

Andy Baumgartner had to walk through a dark valley before ascending to the mountaintop. His son suffered from attention deficit disorder and hyperactivity and, as Baumgartner says, "simply could not find success in school." He dropped out of high school, and his troubles ultimately broke apart the family.

"That was five years ago," Baumgartner says, "and I personally sank to the bottom. I knew I had to pull myself out of it, and since teaching was the one thing I always enjoyed, I threw every bit of my energy back into it."

It was the right prescription. "The next thing I knew," Baumgartner recalls, "I was Richmond County Teacher of the Year, and on the night of the award I met my future wife." His climb back culminated in 1999 when Baumgartner was named Georgia Teacher of the Year and, from the pool of state award winners, was selected by Scholastic, Inc., as the National Teacher of the Year.

Baumgartner can only speculate, modestly, as to why he was chosen. "Part of it certainly has to do with being a male teacher in early education, since that's quite a rarity," he says. He wishes it weren't so rare, especially in a school like Augusta's A. Brian Merry Elementary, where many of the children do not have fathers at home: "Little boys in school need to see men succeeding."

Baumgartner's recognition also stems, he believes, from the fact that he has stayed with the profession for twenty-five years, "and been enthusiastic about it." But what has earned him the most notice, he says, "is that I've always believed in speaking up about what our children and our teachers and our schools need."

Baumgartner's class flows with creative energy—and fun. He wryly attributes the high-octane activity and imagination to two causes: his lifelong love of Broadway, and the fact that he himself is "hyperkinetic" and can only sit still for about five minutes, "which is perfect for kindergarten."

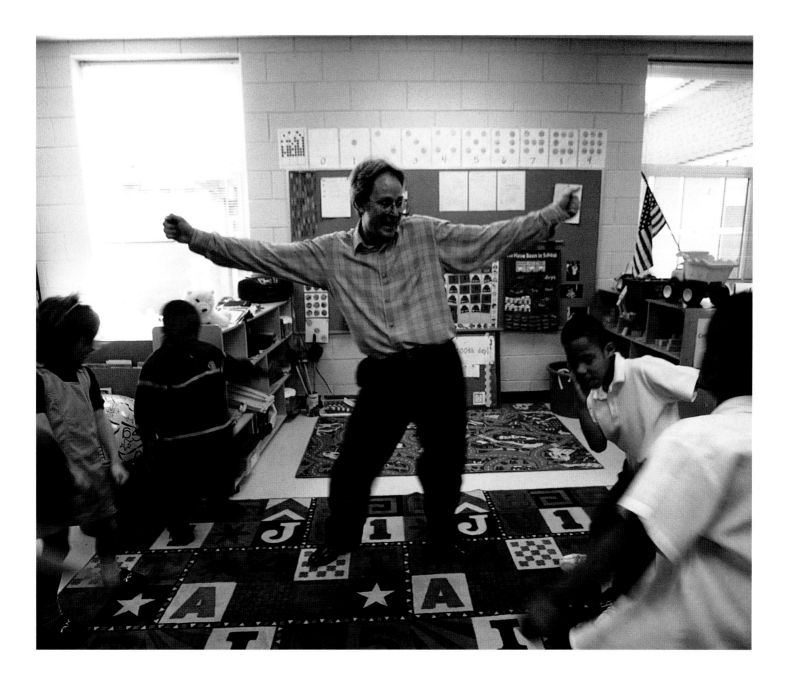

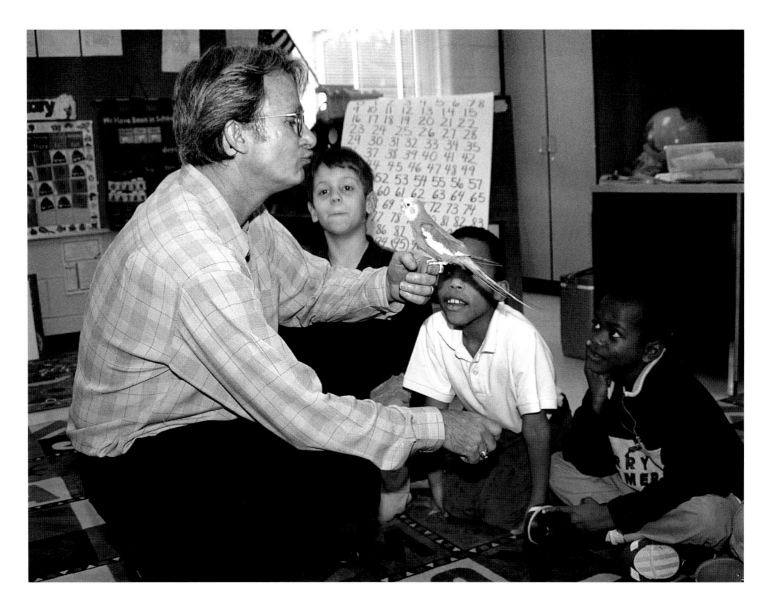

In fact, Baumgartner demurs at the notion that his approach is brilliantly innovative. "Actually," he explains, "I think my virtues are that I am consistent, I believe in what I do, and I believe in the public school system and in our teachers. I have one rule of thumb. Before I do anything in the classroom, before I interact

with any child, I ask myself: Is this the way I would want my children to be taught?"

Certainly, Baumgartner's experiences with his son's scholastic difficulties confirmed his core belief that the classroom, especially for young learners, is a place where failure and self-doubt must be banished: "Very young children should be thinking of school as a wonderful place to be, where they feel whole and accepted, learn and meet with success, and where they have fun." His credo is simple: "Each child who enters my class has a right to enter with dignity and exit with dignity."

Regarding the values that have shaped his teaching, Baumgartner credits two mentors—his very first teacher and his very last. Mrs. Florence Goetter, his kindergarten teacher, realized that a child's first classroom has to be a place of color and excitement, a fun place to be, Baumgartner says. "She made her kindergarten classroom a magic land for children." And Dr. Barbara Stevens, his major professor in graduate school, made him understand his role as an early childhood educator: "She taught us that our job was to work with the entire child, to give our students a sense of themselves and a sense of their dignity. That has always stayed with me."

From the platform afforded him by his award, Baumgartner has had a good look at the complex issues facing public education today, and the view is not always rosy. "Sometimes," he says, "it looks like we've lost sight of our real goal, which should be to turn out lifetime learners. We've replaced that goal with tests and standards. I'm not against standards, but I have a real problem with applying the same standard to every child."

The problem with "education reform," he continues, is that the educators themselves—the teachers—have been eliminated from the discussion. "The politicians don't trust the teachers to solve the problems, when the only solution is good teaching." And good teaching, to him, means "knowing each of your students very well, knowing their strengths and weaknesses, respecting each one as an individual, and being able to teach to each child in the class."

But instead of bemoaning the difficulties that beset the profession today, Baumgartner relishes the challenge ahead: "This is one of the most exciting times educators have ever faced because there is a spotlight on education that nobody is going to be able to turn off. And if we can become the right kind of advocates, we can move education reform in the right direction."

Pat Smith

Third Grade Teacher, Park Lane Elementary School
Broken Arrow, Oklahoma

"If you can't stay excited about this profession, then do everybody a favor and find something else to do."

When I was growing up," says Pat Smith, "girls grew up to be secretaries, nurses, or teachers. And of those three, teaching was the one that interested me."

Smith did become a teacher—an excellent one—first in Wichita, Kansas, and for the past twenty-three years in Broken Arrow, Oklahoma, but her intimation of life's wider possibilities would never leave her. "Then a few years ago," she says, "I did an unusual thing for me. I went to Teachers Space Camp, and it basically changed my life."

Smith's renewed passion for "science and math classes, workshops, conventions, and everything having to do with space exploration" culminated in her creation of BASE, the Broken Arrow Space Experience.

She first persuaded the school district to give her an ancient Dodge van—formerly a mobile classroom—which she, along with a group of high school and college students called the Tulsa Technology Kids, converted into a space shuttle simulator, named Explorer. She applied for and won a Christa McAuliffe Fellowship, which allowed her to equip the shuttle with computers and headsets so that the third-graders aboard the shuttle can communicate with the "launch control" team. During flight, the "astronauts" follow a NASA-style script, but they often encounter problems—signaled by flashing lights—not covered in the script. Because Smith refuses to step in and solve their problems, the students' teamwork and decision-making skills are brought into play.

"My favorite emergency," Smith says, "is when they can't land. Weather problems have come up. So the kids on the ground—the Houston and Kennedy teams—have to decide on a new landing target and then relay that to the shuttle commander. But by the time the commander has turned the page in the script—and finds a blank space—he has forgotten what 'mission control' told him. What this teaches kids is the importance of listening."

In effect, Smith brought the U.S. space program onto the campus of Park Lane Elementary School, and the program has been such a huge success that the shuttle now flies to schools all over the district—and into neighboring districts. And parents are as excited about it as students. As Smith says, "Children from ages three to seventy-six, altogether about 15,000 people, have flown on the space shuttle."

Smith says that after her own experience at Space Camp, she dreamed that all Broken Arrow school kids could "fly" space shuttle missions, and that dream has been largely fulfilled. Here's another dream

that has come true. Of the 2,000 students enrolled in the local high school when Smith applied for the Christa McAuliffe Fellowship, a total of four girls were taking high-level science and math. *Four, total!* Today, after the five years that the BASE program has been in operation, those high-level science and math courses have 40 percent female enrollment. "I think we've made an impact," says Smith. "I really do."

Not surprisingly, Smith believes that if you want to keep teaching, you'd better keep learning. "You have to keep looking for things that interest and excite you, because if you're excited, your students will be excited. On the other hand, if you walk in there like you really don't care, they're not going to care either. Teachers absolutely must model life-long learning."

In today's teaching environment, though, sometimes a teacher's passion for her subject is not enough. "Things have changed since 1969," Smith says, "when you had your little rows of chairs and the children sat quietly at their desks. Now you have to be part-teacher, part-entertainer. The kids today are so used to a fast pace—from TV shows, Nintendo, Play Station. You have to work hard to get and hold their attention."

The secret, as Smith has learned and demonstrated, is to get students involved. "I'm a firm believer in classroom simulations," she says, "whether in science or space or the three little pigs against the wolf. It can be anything. The point is, if you relate what you're teaching to real life, to their life, they'll remember it and they'll understand why they're learning it."

This also brings Smith her ultimate reward. The kids often ask her, she says, what her favorite part of the space shuttle program is, thinking that she'll answer it's the launch, or building the satellite, or the drama of the landing, or some other "exciting" aspect. "I always answer, 'It's watching your faces.'"

Elaborating further: "The concentration on the children's faces when they're reading the script and they've run into a problem they've got to solve, or a dramatic little kid in there saying, 'That's a roger, mission control, and we're out of here for now,' you know, ad libbing a little bit but staying completely in character—I mean, I almost want to cry. They get it, and they love it. And sometimes it makes my heart just pound."

Addie Gaines

Assistant Principal, Seneca Elementary School
Seneca, Missouri

"What one child is best at, another might be worst at. But they all have a 'best thing'—something that they cannot wait to do."

Take something kids love, like stuffed animals; add the excitement of sending and receiving mail; throw in a dash of technology. . . . What have you got? "Addie Gaines's Traveling Mascot Project." And a new kind of learning experience for kids.

Gaines (who taught kindergarten for eleven years before being sent to the principal's office) conceived of the project as a way to get classrooms from different parts of the country communicating with each other and sharing information. Via the Internet, she recruited six classrooms, each in a different state, to participate in the "mascot exchange." According to the guidelines, each class would choose a stuffed animal mascot that represented their area of the country, then, following a prescribed circuit, the mascots would travel from classroom to classroom until they had completed the entire journey. While the mascots made their way via "snail mail," each class used e-mail to provide the others with information about itself, its school and area, and its chosen mascot.

"We put up a map," Gaines says, "so we could track the mascots' progress. We used math to guess the size and weight of the mascots before they arrived and then measured them against our guesses. We composed e-mails and wrote a journal for each mascot (from the animal's point of view). We incorporated all areas of the curriculum."

But the program did even more than that, according to Gaines: "It made the children excited about coming to school."

The exposure to previously unknown parts of the natural world—a bat colony that lives under a highway overpass near Austin, Texas; the life of manatees in Florida's warm waters—was a special bonus. "We did a whole unit on bats," Gaines says. "We even made our own bat cave outside the classroom."

Even the glitches in the project became learning opportunities. When a hurricane in Florida closed the "Mo the Manatee's" school for a week and delayed a mailing, the children in Gaines's class pulled up a weather map on the computer and studied this fierce and fascinating weather phenomenon.

Always innovative, Gaines believes in the individual approach—figuring out where each child is and how to take that child to the next step. "Not everybody is ready to turn to page fifty-two and do the ten problems. You've got to meet the children where they are and take them where they need to go," she says proudly.

Patti Shafer

Personal Finance Teacher, Vandercook Lake High School
Jackson, Michigan

"My advice? Number one, be a listener. Many times students just need you to listen and look them in the eye."

You can forget the ivory tower and the hallowed halls of academe, as far as Patti Shafer is concerned. You'll never hear one of her students ask, "Why do I need to know this?"

This Michigan native is all business, a mindset her students fully appreciate. Along with her duties as career coordinator, she teaches a personal finance course she designed herself and that is now mandatory for every graduating senior at Vandercook Lake High School.

Not that the students need a lot of coercion. With its hands-on approach to such financial nuts and bolts as car-buying, apartment-renting, money-managing, credit, and investing, this is a course students know they need. Not to mention the "stock market game," where teams of students start with an imaginary $100,000 and compete to see who can garner the highest return over a ten-week period. Shafer treats the winning team to dinner at the city's toniest restaurant.

"They love the class because it is so relevant to them personally," Shafer says.

To make the course even more relevant to the real world, Shafer brings in guest lecturers—a financial analyst, car dealer, banker, and other members of the local business community. "The kids really appreciate the different faces, the different perspectives."

Admittedly nontraditional, Shafer would much rather see her students' hands on a lap-top than a textbook. "I am not much of a textbook person. I try to get students outside the walls of the school as much as I can, and the computer plays a huge role. Having information in their heads is not as important as knowing how to find out what they need to know.

"The world is changing," declares Shafer. "Society is changing, and kids are changing. Teaching needs to change accordingly. With all that's going on technologically, there are lots of times when students know more than you do. Fine. Encourage them to bring their knowledge into class and share it."

In addition to the practical value of the material she teaches, Shafer believes her students appreciate her "open and honest" style. "If students see that you really care," she says, "they will respond."

They might even report back. "That's the rewarding part of teaching to me," says Shafer. "When they come back to tell me that what I taught them was valuable to them and that they're putting it to use."

Donald Tedesco

Actionville, Hommocks Middle School
Larchmont, New York

"The first thing I did was shred all my textbooks."

M ake no bones about it: Donald Tedesco became a teacher because he knew it could be done better.

"I always loved learning," he says, "but I didn't like school. School was where I sat at a desk and read and listened and took notes. I was never given an opportunity to share my views or my opinions or my work with anyone else. I hardly ever spoke in class."

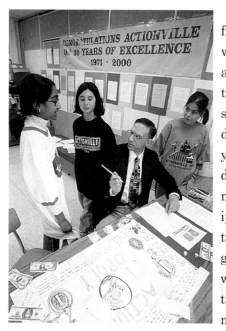

Something was fundamentally wrong, he felt, with a system in which the first day of school was the most dreaded day of the year and the last day of school the most joyously anticipated, and Tedesco told himself that, if given a chance, he would change all that. He would make a difference.

The Westchester County, New York, native gave himself the chance. He majored in Education at Eleanor College and took his advanced degree from Columbia University Teachers College. Immediately upon graduation he began teaching sixth grade social studies at Mamaroneck Avenue School in his home county.

After his third year, during which he had been required to "team teach" a difficult fifth-grade class with three other teachers, he was ready to throw in the towel.

"I was terribly frustrated," Tedesco recalls, "first, by having to team teach with people who don't agree on philosophy, and second, by my realization that I was not reaching every child. That was the key, I thought, to making a difference, and I was not succeeding."

However, instead of accepting his resignation, assistant principal Calvert Schlick offered Tedesco a challenge: "He told me to go home and think about what I would like to do as a teacher, then come in and present my ideas to him."

Tedesco sat down that night with his parents, whom he considers his greatest sources of inspiration,

for a lengthy "brainstorming" session, formulating the most crucial elements in an educational program for children. Out of that session came three ideals: individualized instruction—the concept that every child can be reached on their own academic level and can start from there and move on; learning by doing—the belief that if children are active participants in their education they will retain and enjoy what they learn; and the concept of the classroom as an extension of the outside world.

Out of that same session came the program's name: "We knew it needed to be a place name, and that it should convey a sense of action, so: Actionville." Tedesco was given permission to try the program for one year, but that was just his first hurdle. "An interesting—and critical—thing about the program," he says, "is that it's by choice. I had to present it to the parents in the school district and see if any students wanted to sign up. If nobody signed up, no program."

Fifty students—a mix of fifth- and sixth-graders—made the journey to Actionville in 1971, and over the course of thirty years the program and its core values have been not just validated but acclaimed.

The immense creativity Tedesco would bring to the task was illustrated early on when administrators pointed out to him that since he had, in effect, two classes, he was entitled to have a second teacher "team up" with him. Instead, he asked for the money.

"What I wanted to do was hire a part-time teacher, some teaching assistants, maybe some high school student workers, some senior citizens, or others from the community. I figured that if I had fifty or sixty students and a staff of eight or ten—whether paid or volunteer—then, yes, someone on that staff would be able to reach every child. That was always our first goal, and with what we call our Differentiated Staff, we have the chance to do it."

Pursuing these goals—including hands-on learning and connecting the classroom to the outside world—has put to rout the conventional textbook-centered model. Actionville focuses on experience, project-building, presentation, and group interaction, all of which is supplemented by a steady diet of field trips, two of which last for several days each year. One of the most popular "courses" is called "Film Critics," in which students learn to analyze and write reviews of current movies. The assignment doesn't end by handing in papers. The students share their reviews with each other; then selected ones are posted at the local Blockbuster store.

History books, of course, have been replaced by history skits including props that sometimes find a permanent home in Actionville's (three classroom-sized) free-flowing space. In 1976, as part of the Bicentennial celebration of the various eras of American history, Tedesco's group scavenged an old bathtub to help recreate the days of Prohibition. Twenty-five years later the tub is still there, still painted red, white and blue, but now it's stuffed with pillows and serves as the Actionville Bath Chair—a favorite reading spot for the kids.

It hasn't been easy. Tedesco has compared running the program to rowing a boat up Niagara Falls. Old attitudes die hard: how can students having that much fun be learning anything? Once, Tedesco recalls, an angry teacher came banging on his door, willing to bet that Tedesco's students could not name the mountain range that lies between France and Spain. "You may be right," Tedesco told him. "But I can promise you one thing: they know how to find out."

Such is this wise teacher's philosophy: "We can stand here and talk and talk for 180 days, or we can give our students the building blocks for learning. We can give them the confidence to find answers on their own. The tools are much more important than the facts, and Actionville is a tool-building place."

Advice for others who would be teachers? "Follow your dreams," Tedesco says. "I know it's tough. There is always great pressure to follow everyone else, to do the same old thing. But if you're not following your own convictions, you'll never relate to your children."

The ultimate affirmation, he says, is "to be able to look back someday and say, 'I made a difference, even if it was just in one child's life.'"

Randy Albrandt

Physics Teacher, Pomona High School
Arvada, Colorado

"The students are part of the process now, instead of just being on the receiving end. That's a good thing."

It all started innocently enough. Always on the lookout for hands-on activities to get his physics students involved, Randy Albrandt began enhancing a demonstration in sound by mounting mirrors onto a speaker and using a laser to create "a mini-laser show." It was fun, engaging, so . . .

"One year I thought, 'Why don't I get the seminar class to put one of these together?'" Albrandt recalls. "That was nine years ago. It was a crude effort, but the kids really loved it, and from there it just blossomed."

Today, Albrandt's award-winning Laser Optics program serves as yet another example of the heights to which students can soar if given the opportunity and a little encouragement from a gifted teacher.

These students spend seven weeks (including some Saturdays) creating a professional-quality laser show. In addition to mastering the basics of laser physics, the kids work together to overcome a number of interesting challenges. They have to create a perfectly stable system in which the mirrors remain absolutely stationary. They have to "gap in" the video so that the visuals will work fluently. They have to choreograph the music and the images. Finally, they

have to know the system so well that they can operate it in the dark. "We expect it to be of the same high quality that you would find at a planetarium," Albrandt says.

The finished show is presented to several audiences: the school's other science students, the parents of the creators, an alumni group of former project workers who critique it, and, most recently, groups of elementary school students "who are just amazed at it."

What the students gain from such an experience—and what Albrandt gains—can be seen as the culmination of a process that began when Albrandt started teaching twenty-seven years ago. "That first year made me realize I had a lot to learn," he recalls. "I really focused on teaching the material, but I failed to make a connection with the kids."

The success of the Laser Optics project illustrates the distance Albrandt has traveled in the meantime. "This laser project is entirely theirs. They own it. And it proves that if you give students a piece of the program, they'll learn more, get more excited, and enjoy it more. That, in turn, has helped me in everything I do."

Estelle Aden

Voice and Acting Teacher, Hofstra University
Long Island, New York

"I have had the great privilege of hearing my former students say to me, 'You have changed my life.'"

Estelle Aden doesn't have to wonder how her former students are faring out in the real world beyond the university.

Phil Rosenthal, for example, was recently profiled in a front-page article in the *New York Times*. Not that Aden needed the *Times* to tell her that Rosenthal is now the hugely successful writer of the hit sitcom *Everybody Loves Raymond*, or that he and his wife Monica—also a former student of Aden's and "a wonderful actress"—now have two children.

And there's Tom McGowan, who was nominated for a Tony Award for his performance in *La Bête*. "He was the understudy for Ron Silver," recounts Aden, "and Silver left suddenly just as the production was about to premier in Boston. There's a forty-five-minute monologue in the first act, and Tom had to do it 'on book,' which means he was holding the script. He was unbelievable. He got a standing ovation."

And Brian Dennehy's daughter Liz—"a beautiful girl and wonderful talent," Aden says, "now working in theatre out in Los Angeles." And Jim Barbour, who starred in *Beauty and the Beast* and is currently headlining in *Jane Eyre*—"a stunning young man."

Aden, of course, doesn't claim to have supplied the talent that has fueled the successful careers of these and hundreds of other young actors who have been her students at Hofstra University during her thirty-year career there. "They have the talent already," she says. "They have the potential. But they have to grow and they have to have roots. That's what I try to give them—roots that will continue to nourish them over the years."

Early in her career, Aden was impressed by pioneers in the field of creative drama for children. "They were saying, 'Listen to the children. Let them out of their chairs and don't make them prisoners in those seats.' And that's what I try to do with these young people. I give them the opportunity to discover, to let their hair down, to be free. Teaching, to me," she emphasizes, "is not intruding."

Aden says her approach is to ask herself, "What does this class need?" And one of the answers, almost invariably, is to be willing to take risks. Aden particularly loves to use Brian Dennehy's story as an example. "He told my class that he used to work in finance, and he was sitting at his desk one day when he looked up to see this man, one of his coworkers, getting out of the elevator. The man was carrying

science majors and the business majors come into my classes. It's my chance to tell them, 'Yes, along with your sales, along with your stocks and bonds, along with your medicine, take yourself to an off-Broadway theater, and let yourself be transported into another world. It's vital to your life if you're going to be a fully functioning person.'"

And ultimately, to help her students become "fully functioning" is what Aden, and Hofstra, are all about. "A liberal education, by definition, means getting exposed to as much as you possibly can. Whether you are an actor or a banker, you should know astronomy, you should know mathematics, you should know history, you should know languages. The idea is to keep opening your educational vistas."

Learning never stops for teachers, too. "The great thing about my job here," Aden says, "is that every student I teach, every person I meet, brings something new to my experience. So often in this world we hurry past each other, but believe me, my students and I take a good look at each other."

Having studied to be an actress and been "seriously in theater" for several years after graduation, Aden remains amazed at the satisfaction she's found in the life of a teacher. "Not only did I realize that I could do a great deal, but I saw also that this was a career where I didn't have to be egocentric. It wasn't 'me, me, me.' It was 'them, them, them.' I really feel that I am at a beautiful time in my life."

some sort of package, and he was so harried and stooped that he looked like he was walking his last mile. Brian said, 'I closed my desk, got up and walked out, and I never looked back.'"

That's risk-taking. "You have to be really secure in yourself, too," Aden adds, "because you never know where it's going to take you and you have to be willing to go there."

It's important to Aden that not all of her students are drama majors, just as it's important that all of her students, whatever their major, are receiving an excellent liberal arts education. "I love it when the

Dr. James Reed

Principal, John Ireland Elementary School
Dallas, Texas

"Knowing how to listen, really listen; that's the key."

D r. James Reed's innumerable press clippings and award citations paint a picture of an innovative, charismatic, fun-loving, kid-oriented educator who is making a big difference in the lives of elementary school children in Dallas, Texas. And that picture is accurate.

This is the administrator who has set an example for students and staff alike by not having missed a day of work in more than twenty-five years. A principal who made his school's Reading at Home (RAH) program a huge success by issuing an irresistible challenge: if the students met their goal of total min-

utes read at home, he would don a goofy costume and conduct business for a day up on the school's roof.

This is the educator whose hands-on philosophy and inspirational message—"If it is to be, it is up to me"—

have in fact made a difference, not only at John Ireland Elementary but at two schools where he previously served as principal.

And it's quite true: Reed's success stems from the fact that he loves the kids—and enjoys them. "That's the rudiment," Reed says. "You can't come to this job, with its barrels of problems and concerns and challenges, if you don't enjoy kids." In fact, he seems almost one of them, for reasons he himself can't quite explain. "Maybe it's that I'm hyper like so many kids are. I can't sit down any more than they can. But whatever it is, I really do have an ability to relate to them. It's like I've never grown up myself."

Thus the open-door policy whereby anybody can come see him in his office at any time, no appointment necessary. Thus the fervent belief in the "one-on-one" approach, the commitment to knowing every student, and every student's family. And thus the ability to see that, to compete in a culture dominated by TV, video games, and other such amusements, schools have to make education an enjoyable experience.

Yet the considerable and much-deserved acclaim does not do justice to Dr. Reed, a serious, thoughtful, and utterly dedicated professional who deals every day

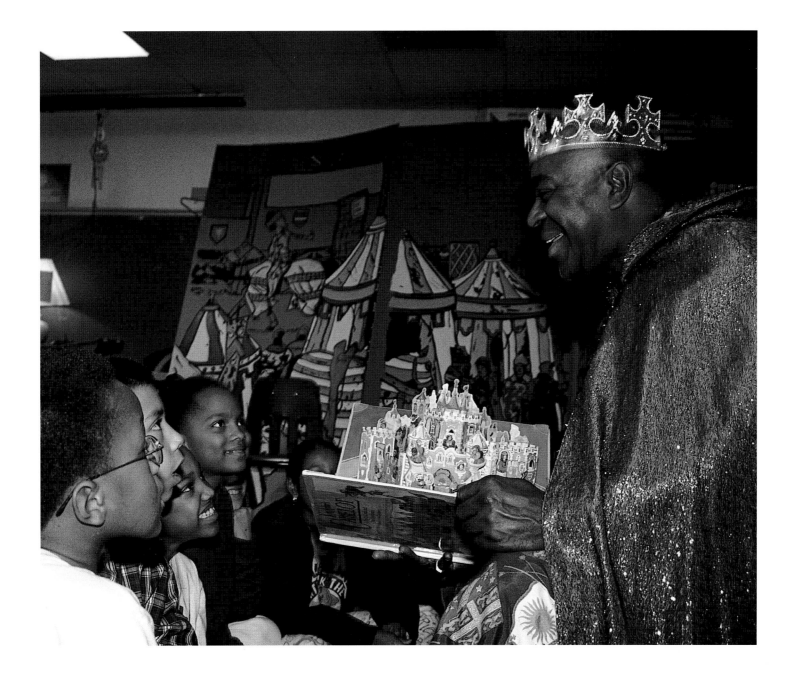

with education's toughest and most complex issues.

It begins with the demographics. "Eighty-five percent of the families with kids in this school are on the low end socioeconomically," Reed explains. "Which means that most of the parents are on welfare." This basic fact ripples outward with overlapping problems. Parents may not be educationally minded—"Parent apathy is overwhelming," Reed says—and yet parents rely on the school to take care of the children. "It's been said that parents drop their kids off when they are five years old and pick them up when they're eighteen," Reed adds.

Discipline is equally complicated. Reed has the authority to levy suspensions when such punishment is justified, but he has to consider that the free breakfast and lunch provided at school are important to the child's nutrition and perhaps to the family's economic stability. Meanwhile, the other time-honored remedy, paddling, has become fraught with political liability. Indeed, before the school year begins, Reed offers parents the opportunity to rule out corporal punishment for their children, "and if the parents won't condone it," he says, "we must find other alternatives." Reed learned this lesson the hard way during his early years as a principal when he unwittingly broke a cultural taboo by paddling a young Hispanic girl. "The girl's mother had to keep the father from killing me," he recalls. "He really wanted to kill me."

In the face of apathetic and sometimes hostile parents, and children often saddled with problems from home, Reed also faces an ongoing crisis regarding teacher morale. "Getting teachers to come to work is a really big problem," he admits. The ten days off from work per year allowed by the school system are exceeded regularly. "I've got people in the 'dock situation,'" Reed says. "Their ten days are up and now they're losing a day's pay when they don't show up."

What's more, if teachers find the situation too difficult, they simply transfer out of the school—a lack of loyalty to the school and community that Reed finds troubling. "When I started," he says, "you had to be in a school for three years before you could even contemplate a transfer. Now they can start in September and apply for a transfer in March. It's like free agency in football. There's no allegiance any more."

So Dr. Reed finds himself in the middle—desperately reaching out with one hand to involve parents in their child's education, and with the other trying to hold on to the kind of teachers in whom parents can have confidence. "I have found teaching the teachers how to deal with the parents to be the most challenging part of the job," Reed says.

But he's at it. Every day. And he's not planning to quit. Keep the accolades coming.

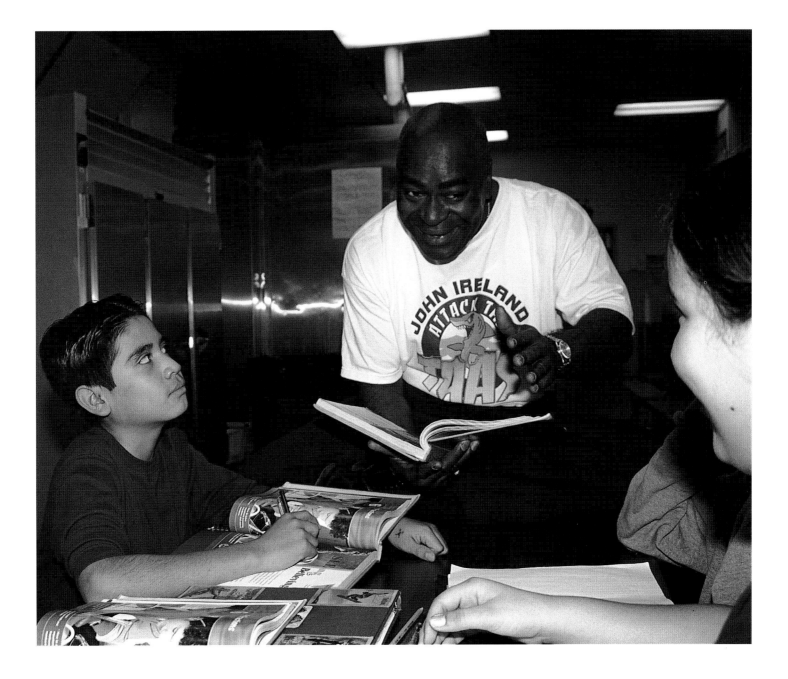

Debbie Wallis

Central Elementary School
Pleasant Grove, Utah

"We need to always remember why we got into teaching—and never lose sight of the child."

The kids at Central Elementary School in Pleasant Grove, Utah, are looking for new worlds to conquer. They had already been traveling through outer space, thanks to their school's Christa McAuliffe Space Education Center. And now, through Debbie Wallis's innovative "Magellan—Underwater Edventures" project, they're cruising the oceans in their own submarine.

"When the navy ran a 'name that ship' contest a few years back," Wallis explains, "I saw how interested my students were in the ocean and I didn't want that interest to die." She fanned the flames by initiating a partnership between her school and the navy submarine USS *Salt Lake City*, which opened up a direct source of information and material for her eager students to digest.

It then occurred to Wallis that it wouldn't be difficult to convert a space ship into a submarine, and once she had secured a grant to cover the costs, the Magellan project was born.

Actually, three of the space program's "modules" undergo conversion for oceanographic purposes. First, there's Magellan, "the base ship and control center from which the submarine is launched," says Wallis.

Odyssey is the actual submarine (simulator). "It's an eight-man sub," Wallis explains, "which sets out with a precise mission to accomplish, following orders transmitted from Magellan. Right now there's a bad guy leaking toxic waste into the ocean, and they're using their sensors to track him down."

Then there's Star Lab, an inflatable dome on which images are projected. "It's like you're looking at the earth from the inside," Wallis says. "You can see tectonic plates; you can see what causes volcanoes."

The students' enthusiasm has been incredible. "They're so excited, and there's nothing better than seeing them go for something on their own. This is really student driven," Wallis says.

Wallis is quick to pass along the credit for the program's success—especially to her principal and to the director of the Space Education Center—but she doesn't mind describing herself as a go-getter. "When I see a need, or something my students need, I don't ask. I go straight to the people I think would like to help and get it going."

Call Wallis a catalyst. When you're trying to launch a submarine, you need one.

Harvey Burniston Jr.

Agriculture/Horticulture Teacher, Johnson County Vocational School
Mountain City, Tennessee

"I think the keys to success in teaching are being excited about what you're doing, sharing that enthusiasm, and teaching the student instead of just the subject."

Harvey Burniston Jr. thinks positively. He plasters the walls of his classroom with inspirational quotes and messages so that his students and associates will inhale the atmosphere of enthusiasm and energy he tries to create.

"Success breeds success" is one he likes. Even closer to his heart is "Choose an occupation you love and you'll never have to work a day in your life."

But one that clearly shapes his guiding spirit is

"Necessity is the mother of invention."

This former Florida-based forester with a bent for horticulture arrived in Mountain City, Tennessee, in 1982 to head up the agriculture program at Johnson County Vocational School. "At that time agriculture wasn't doing very

well in the United States. Farms were being foreclosed, and the program here was down to fewer than a hundred students. They were thinking about reducing it even more. I could see right away that if I wanted a job for more than a year or so I was going to have to do something," Burniston recalls.

The first thing he did was survey the students to find out what their interest was. "Fortunately, it was the same as mine—horticulture." That led to his second step: acquiring an unused greenhouse from the State of Tennessee. The only problem was that it was located at the other end of the state, five hundred miles away. "I took eight students, one other teacher, and an electrician; we drove nine hours to get there and we dismantled that greenhouse and turned around and brought it back here." The local county commission had ponied up $5,000 to cover the costs, so, in essence, Burniston says, "they got a $65,000 greenhouse for $5,000."

That's when success started breeding success. "We just kind of kept growing," Burniston explains. "The students added a classroom onto the greenhouse. Then, with money we raised selling plants, we built a

second greenhouse. On one of our field trips down to Epcot in Florida, we got interested in hydroponics, so we came back and built a hydroponics greenhouse."

Burniston and his four hundred students now run a full-fledged "alternative farming center," the chief marvel of which is the geothermally-heated aquacenter for growing hanging and bedding plants, hydroponic crops, and fish (koi and tilapia). The water-grown crops include lettuce—two to three hundred heads harvested per week—tomatoes, cucumbers, and bell peppers, all of which they sell to local grocery stores and the school's food service program.

Obviously, the basics of running a business—including production, sales, and marketing—is a relatively small part of the education that Burniston's students receive. "They have to use their chemistry, their biology, their math. They've got to control the pH in all the tanks; they've got to pollinate the flowers and use biological controls on the pest populations," Burniston says.

But the educational program by no means ends with a solid foundation in the agricultural sciences. "We're constantly giving tours here," Burniston explains. "The students lead them, and it does wonders for their self-esteem and self-confidence, not to mention how it improves their English and public speaking skills." In effect, the students leading tours are teaching the material, which Harvey regards as the best possible learning device. "If my students just listen to me lecture to them in class," he says, "they'll retain 10 percent. But if they have to turn around and teach what I teach them, they'll retain 95 percent."

In fact, Burniston is not a big believer in "teaching by the book." He says he likes to start off on the first day of class by holding up the textbook and offering two alternatives: they can go through the book page by page, make their outlines, and take the tests at the end of each chapter; or they can take the concepts out of the book and head to the greenhouse. "I've never had anybody choose the book yet," he says.

His natural gift for innovation, for finding a better way, is what led Burniston to become a teacher in the first place. He wasn't one of those people destined for the profession, he says. "Actually, I used to sit in class in high school and think it was pretty boring. But I also thought I could do it better. I also thought I could make it fun."

For nineteen years he has been doing it better and making it fun, and in the process he's created a program that has won him (and his students, he insists) tremendous recognition. "We've lost count in the last year or so," Burniston says, "but I know we've had visitors from at least thirty states and eight foreign countries." Burniston appreciates the acclaim, he says, not on his own behalf, but because historically agriculture and vocational teachers have not shared in the limelight. "I think agriculture programs all over the country will benefit from what we have been doing here."

Certainly, the students at Johnson County Vocational School, area farmers, and the Mountain City community have benefited immensely from Burniston's ingenuity, creativity, and infectious can-do spirit. "It's your attitude, not your aptitude, that determines your altitude in life," he says.

Charles Bullard

Music and Band Director, Holland High School
Holland, Michigan

"Of all the things my father taught me, the most important lesson was to treat everyone else like you'd want to be treated if you were at the other end of the line. How can you beat that? If you could get people to practice that, wouldn't we have a wonderful world?"

Charles Bullard, the long-time and much-beloved music and band director at Holland High School in Holland, Michigan, insists that he was *not* the inspiration for Mr. Holland in the acclaimed Richard Dreyfuss movie *Mr. Holland's Opus*.

Yes, the movie's screenwriter, Patrick Duncan, was a student in the Holland Public School System, but he didn't go to Holland High. And besides, says Bullard, "Patrick says he was inspired by a teacher he had back in the sixties, long before I came to this district."

But a lot of people would argue that Bullard *could* have been the real-life Mr. Holland prototype. And not merely because of his striking physical resemblance to Dreyfuss.

The real similarity lies in the fact that Bullard has made a habit—a career—out of lifting his students to a level of achievement that would have seemed impossible. Raising the bar started the day he took the job at Holland twenty-one years ago, when his supervisor challenged him to develop a program good enough to compete in the Tournament of Roses Parade.

"I thought he was out of his mind," Bullard says, "but if he was willing to set that standard, then I was willing to strive for it. I laid out a five-year plan and we got to work, and sure enough, we got the invitation in 1986 to appear the following year."

Since that time, Holland High School's Marching Dutchman Band has compiled a record of honors and achievements that defies comparison. A few of the highlights: a second appearance at the 1995 Tournament of Roses Parade; the 1990 Orange Bowl Parade; Ronald Reagan's 1985 Inaugural Parade; two appearances at Disneyland in California and fifteen appearances at Disney World in Florida; three appearances at the Indianapolis 500 Pre-Race Parade; and three appearances in America's Thanksgiving Day Parade in Detroit.

Bullard's secret? A fierce dedication born of love for his students. "I'm always here," Bullard states frankly. "I make sure to give the program the time I think it needs, but, more important, I always give the students as much time as it takes for them to be successful."

No doubt that's why seven of his former students are now high school band directors in Michigan alone.

What's not a secret? Bullard loves what he does. "Even after all these years, I literally race to work in the morning."

Sister Ann Gelles

Braille Specialist, California School for the Blind
Fremont, California

"I try to live by these words from *The Little Prince*: 'What is essential is invisible to the eyes. It's with the heart that one sees rightly.'"

Born two and a half months premature, Sister Ann Gelles lost her vision when too much oxygen in her incubator destroyed her optic nerve. But her spirit, clearly, was not damaged.

"I learned pretty early that I would sometimes have to be my own advocate," Gelles say. "Some teachers were inclined to tell me, 'Oh, that's okay, honey, it's not important for you to learn that.' And I would always say, 'Well, if everybody else has to learn it, then I want to learn it, too.'"

Her family helped foster a strong sense of independence. "They always insisted that I was Annie first and blind second," explains Gelles, "and my father always had me doing everything the family did—horseback riding, swimming, camping, ice skating. Even if I wasn't very good, at least I had the joy of participating."

Others haven't always been so supportive. The Sisterhood at the Convent of the Holy Family, where Gelles felt she had found a vocation, was not sure they wanted to take a chance on a blind person. The University of Nevada at Reno wasn't sure Gelles could do her student teaching in a regular classroom.

"People kept trying to close the door," Gelles recalls.

But she persisted, driven by her knowledge of how much she had to offer, as well as by her determination to prove the naysayers wrong. This year she celebrates her twenty-fifth anniversary as a Sister of the Holy Family and her fifteenth year as a teacher—the last five at the California School for the Blind. "Hopefully," she says, "the blind people who come after me will find more doors open for them because of what I was able to accomplish."

The lesson she learned from her own family's attitude of inclusion continues to guide her teaching. Gelles rewrites her favorite books in Braille "so the kids will have the excitement of reading regular books." And, more recently, she has even devised a Braille version of *Who Wants to Be a Millionaire*?

"It's been a great success," Gelles says. "The kids love it. And the more advanced students get to act as 'lifelines,' which is a great boost to their self-esteem."

It's all part of her mission to make her students see themselves as "able, not disabled," says Gelles. "That's the important thing."

Stedman Graham

**CEO, S. Graham & Associates and Adjunct Professor, Northwestern University
Chicago, Illinois**

"As Gandhi says, 'You must become the change you seek in the world.' You must become inseparable from what you teach."

Stedman Graham didn't set out to be a teacher. In fact, he grew up wanting to play professional basketball in the NBA. By having to give up that dream and move on, he learned a valuable lesson. "What I try to do," Graham says, "is not be a product of my past, buying into what I couldn't do. Now I try to focus on what I can do, to focus on my strengths."

That insight led to an even greater one: that success is a *process*. It's not a matter of fate, or destiny, or circumstances. It's something that we can learn how to achieve. Once Graham had realized that

truth, once he had discovered and articulated the process, once he had written a best-selling book (*You Can Make It Happen*) outlining the process in a nine-step program, then, he realized, it was time to start teaching.

"When I made that discovery—that there is a process for success—it meant freedom for me, and I realized that it could mean freedom for so many other people, too. Once you understand the process, you can create anything you want," he says.

Graham's passion for sharing his system is also motivated by the strong sense of community he enjoyed during his childhood years in the small town of Whitesboro, New Jersey. "I grew up around a lot of teachers, coaches, scout leaders, church leaders—folks who believed in helping and giving back," he says. "We had a great support system, and I believe you need that. It sets a great example, and I see what I do now as a way of saying thanks. I always felt my responsibility was to give back in turn."

So he teaches—to corporate executives and managers, seminar participants, graduate students at Northwestern's Kellogg Graduate School of Management, and to kids in Chicago's public school system, where his Athletes Against Drugs program develops tomorrow's leaders. "I didn't grow up with a program or a message," Graham says. "It didn't happen until I was in my early thirties, but when I discovered this process for success, I also saw that I could try to teach it to the world."

His mission became energized by urgency. "So many people don't know how to take control of their lives," he says, "and it's because they're not given the right information. There are millions of people who believe they can't make it because of the color of their skin, or because of their gender, or because of their socioeconomic situation, or because of something their parents did or didn't do. In fact," he continues, "most of us are going through the motions—doing the same thing over and over and over day after day—not realizing that we have to have a vision for ourselves that extends beyond our daily routine." Without this vision, Graham believes, traditional education stands to lose much of its potential value. "How many college freshmen arrive on campus basically clueless and spend the next four years aimlessly looking for themselves, hoping the courses will do the guiding for them, never really thinking about what they want to get out of this experience? What they're doing is giving up all control to the educational process."

Graham's approach is to start with the individual, to teach that person how to begin the process of discovering who he or she is, to build a foundation on what that person is passionate about, and then to apply the education accordingly. "Now," says Stedman, "you're using the educational process to enhance who you really are."

Graham takes special pleasure in teaching his MBA students at Northwestern. "Even graduate students are often still in the dark in terms of really evaluating themselves and where they want to go. And to watch this process take hold, to see the light bulb come on, and then at the end of the ten-week course to have them come back and say, 'this has been the most rewarding experience in my life'—well, that's what it's all about. Getting people to discover themselves is very fascinating . . . for them and for me."

Graham believes in enabling and empowering—in giving the right tools to people, whether they're in the classroom or in executive seminars. "On any level, it's easy to give up on yourself," he says. "But if you understand there's a process and that you can create whatever you want once you understand it—that's the greatest freedom in the world."

He speaks with the conviction that comes only from personal experience: "That's what happened to me," he says. "Once I understood that, I said, 'Oh, this is what it's all about.'" All else follows: "It's a realization that gives you the ability to compete, and be free, and develop, and build, and explore, and dream, and then achieve your dreams." If good teaching—as Graham suggests—is teaching what you love so that your passion for your work makes you a lifelong learner, it seems clear that he meets his own criteria.

"This idea of a process for success is the greatest thing I've ever discovered in my life," Graham says. "And to be able to share it and teach it around the world is the greatest gift I could have gotten."

Xóchitl Fuhriman-Ebert

English as a Second Language Program Director, Ontario Middle School
Ontario, Oregon

"Being a teacher is our contribution to society. We are changing the future one student at a time."

When Xóchitl Fuhriman-Ebert moved with her family from Mexico to Utah just in time for her to enter grade school, a long struggle began.

"We spoke no English at home," Xóchitl recalls, "because it was important to my parents to retain our Spanish heritage. So I had a hard time in school." The worst part of the experience was being summarily pulled out of her regular classes to attend special classes. "I really hated that," she says.

She persevered throughout high school, still struggling but ultimately graduating. College gave her a chance to catch up, and "amazingly enough," she says, "I did very well." But as Xóchitl embarked upon her teaching career in eastern Oregon, in a district with many Hispanic children facing the same obstacles she had overcome, she found herself back at square one.

"After teaching Spanish one year here [at Ontario]," says Xóchitl, "they put me in charge of the ESL (English as a Second Language) program. There was 1 of me and 130 kids, and it was impossible. I did it for two years and wanted to quit. There was simply no way for me to meet their needs by myself. I was embarrassed when my students did poorly."

But instead of quitting, which is not in her nature, she wrote a grant proposal with the intent of bolstering the school's ESL program. She received sufficient funding to immediately hire two additional teachers, and she has been writing proposals ever since—seeking grants that enrich the program, her students, and her fellow teachers.

"With grant funding we have just sent twelve ESL students to Washington, D.C.," says Xóchitl, "an opportunity that they could never have had and one that might change their lives forever." With a recent Title 7 grant, Xóchitl will be taking a group of Anglo teachers down to Central Mexico, where many of their students are from. "These teachers will come back with an appreciation of the language, the culture. They will be able to make connections with these students."

For her untiring efforts and unyielding spirit, Xóchitl Fuhriman-Ebert was named Oregon Teacher of the Year in 2000. What drives that effort is easy to explain: "I just want to help students who are struggling. I vowed I would find a better way than pulling kids out of class."

Janet Popper

Fourth Grade Teacher, Northside Elementary School
Ann Arbor, Michigan

"My advice to new teachers? Get a lot of sleep and eat a good breakfast."

Janet Popper took a long detour on the way to her teaching career. She had just finished her degree in education when the hospital where she was working offered her a full-time supervisory job.

"They paid more than a teaching job would," Popper recalls, "and since I was divorced and supporting a young child, I stayed at the hospital. That was twenty-six years ago."

After advancing to the rank of hospital administrator, remarrying, and then giving up her job to start another family, Popper says she thought again about her career. "My husband advised me to do something I loved, something I would find more meaningful than assisting professionals, so I returned to school, got a Masters degree in social work, and became a school social worker." But being back inside the school building, says Popper, rekindled her interest in the teaching profession.

"As a social worker I had learned to look at the individual as a whole person, as well as at the world around them and their interaction with it, and I thought that would be a marvelous technique to take into the classroom."

She was right, and during her four years at

Northside Elementary School her students have been much enriched by Popper's holistic philosophy. On a recent field trip to the campus of the University of Michigan, her students browsed through the reference room in the Graduate Library (since fourth-graders are beginning to write research papers); they visited the art museum, where they focused on three paintings—a Picasso, a Monet, and a Whistler—and were

encouraged to think about how the paintings made them feel; they rode the campus commuter bus to a cafeteria and ordered a lunch whose price could not exceed the five dollars each child was allotted.

Another outing took the class to the Ann Arbor

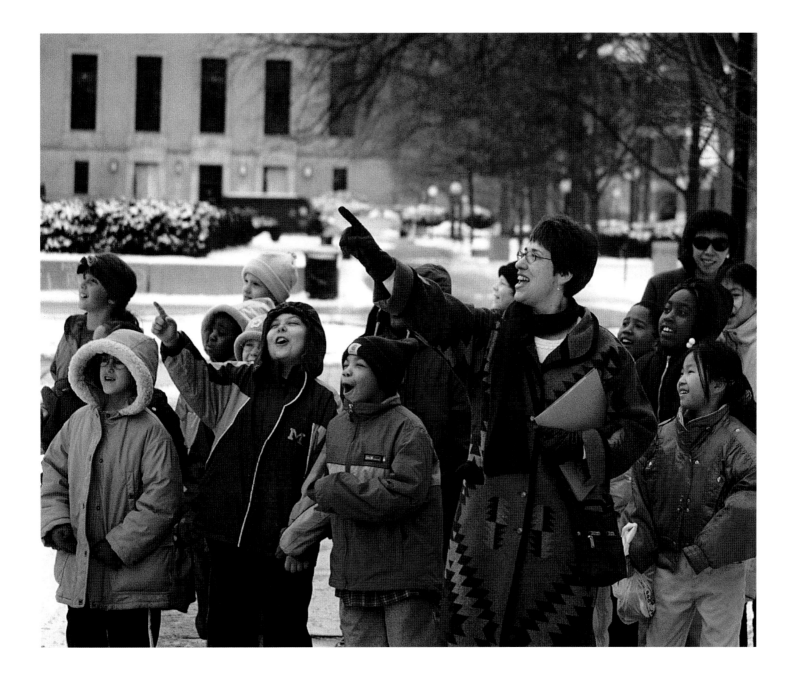

farmer's market—a walk of about a mile and a half—where the students interviewed the farmers about the foods for sale. "We found out how long it takes to grow zucchini," says Popper, "and how long it takes to make jam. One student asked a farmer the size of the biggest carrot he had ever seen; another asked how you know when to pick a raspberry." They returned to the class and put together a book containing all the information they had discovered.

On another occasion Popper rented an ice skating rink and took the class ice skating. "Many of them had never been skating before," she says, "and it turned into a joyous experience, a wonderful lesson in willingness to try something for the first time." It also provided a valuable analogy: "When they are having a difficult time with classroom work, like maybe division, I say, 'Remember when we went ice skating, how hard it was at first and how it got easier with practice."

In addition to the fun, excitement, and educational value of these activities in and of themselves, Popper has a larger purpose in mind. "My social work background teaches me that a community has shared experiences, and what I'm doing in this classroom is building a community. The kids will ask each other—remember when we did this together or that together. The experiences build on each other, and, as part of that process, they teach us about caring for each other."

Caring for each other, for the whole person, is the focus of much of the in-school class activity as well. Each day begins with a "community circle," in

which the students discuss how they're feeling and what they did the night before. This is also their chance to offer "appreciation statements" to each other, another positive bonding experience. "Just like

adults with their cup of coffee," says Popper, "children need a few minutes to socialize at the start of the day. They don't want to come in with their backpacks and sit right down and start working."

Popper also makes time for plenty of "one-on-one conferencing" with each child. "It's all part of caring," she says. "Caring whether they're getting along with their friends, whether they're learning their math and, if not, why not." She's a strong believer in journal writing, too, not only as a way of improving skills, but to express thoughts and feelings, of sharing. "They write to me about what they're thinking, and I write back. So we have ongoing communication," Popper says.

But there is one more aspect of caring, Popper believes: expecting the most and demanding it. "I don't give them answers," she says. "That really makes them hate me sometimes, because they want the answer and they want it now, but teaching them to think is the most important thing of all."

It also provides the greatest reward for student and teacher: "Whenever I hear that 'Oh, I get it, Ms. Popper,' that is the real beauty of it for me."

Conni Gordon

Art Teacher
Miami Beach, Florida

"You should place importance on what you can do for others, not what you do for yourself. Believe me, it will come back to you, just as it has come back to me."

Conni Gordon may well be the only teacher in the *Guinness Book of World Records*. Having taught her system to over 16 million people, she officially holds the record as the world's most prolific art teacher.

She got off to a fast start. Her first "class" consisted of 50,000 marines during World War II. "I was part of an entertainment program, but in this case, the plane with the rest of the entertainers didn't show up. What was I going to do? Well, we quickly distributed all the pencils and paper we could find, and right then and there I came up with a show called 'Draw Your Own Conclusion.' I taught them how to do a portrait."

Out of that spontaneous creative moment grew Gordon's patented Four-Step Method (Outline, Under-colors, Over-colors, Details), by which she guarantees that anyone can create a beautiful picture in a matter of moments. The unparalleled success of the system has made Gordon a popular TV talk show guest—with six appearances on David Letterman's show alone—and, ultimately, an acclaimed motivational speaker.

When it occurred to Gordon that her Four-Step Method could be easily applied to encouraging creative thinking in the business arena (where the steps translated into Think-it, Ink-it, Link-it, and Sync-it), the audience for her positive message increased exponentially.

But whether she's teaching six- and seven-year-olds at one of her famous Paint Parties or CEO's at a corporate training seminar, Gordon's goal is the same: "The most important thing they learn is creative motivation—the fact that they can do something they never realized they could do." Gordon says it's amazing to watch these CEOs, totally skeptical at first about a "painting workshop," come to embrace the importance of self-expression and the power of total creativity. "By the end of the seminar," she says, "I have them exclaiming, 'I did this! This is me!'"

Gordon concedes that a very small percentage of her students will continue to create art, but that doesn't matter. "I just want to open the door for people to believe in themselves, to be more than even they think they can. That's what is meaningful to me."

Ultimately, it's not the art itself that's important: "If you touch people for a few minutes of their life," says Gordon, "if you change them, you're a teacher."

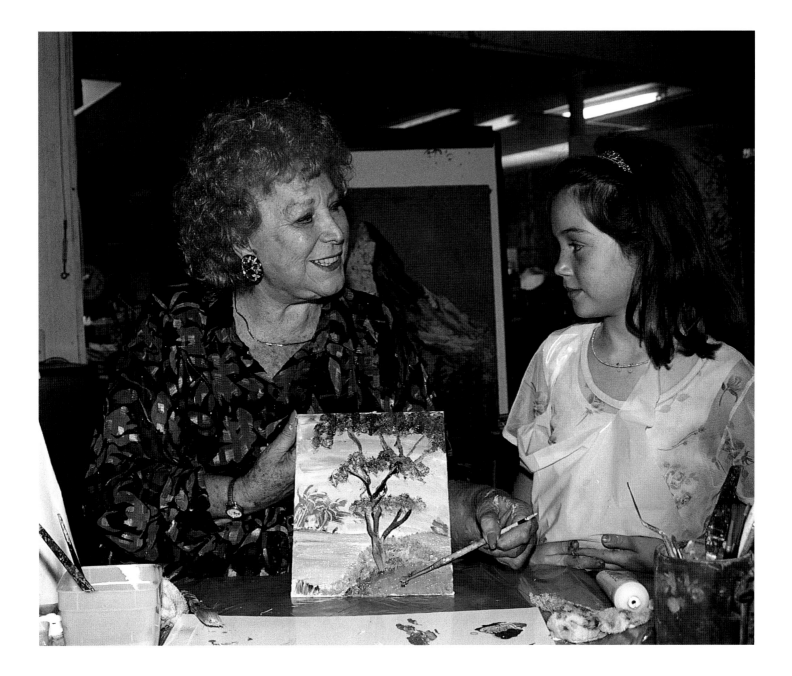

Rob Seideman

Founder and Teacher, Cooking School of Aspen
Aspen, Colorado

"I'm totally drawn to those activities that instill a sense of self-confidence and independence in kids."

Rob Seideman never set out to be a teacher, and he doesn't consider himself a teacher. But to an amazing degree he loves . . . okay, call it "sharing information."

Seideman currently operates, as part of his Cooking School of Aspen, one of the nation's best cooking schools for kids, according to *Gourmet* magazine. Before that, he ran a successful children's martial arts program in Aspen. Before that, during his life as a writer, he taught in the Writers in the School Program. Recently he's begun teaching kids to ski.

In every case, the syndrome follows the same pattern. "I reach a certain level of proficiency, and something kicks in," says Seideman. "I really can't explain it. I realize what these activities have meant to me, and I want to share them with kids."

Writing, for example, had been Seideman's first career. He was a published author, and had even founded a writing school in Aspen. "But when I felt understood writing well enough to teach it," he says, "I was driven to share it with kids. Think what a huge impact being able to write well makes on kids."

The same with martial arts. "After many years of studying it myself, after reaching that level of

proficiency, I realized that this was something that could change kids' lives. Imagine the self-confidence you would have by becoming a black belt while you're in your teens."

And as for cooking, Seideman has had a passion for that art as long as he can remember. But again, it was only after deciding to open the school, and then preparing himself by taking roughly five hundred cooking classes, that the compulsion to "share this information with kids" took hold.

Just don't call it teaching. "The thing is," Seideman explains, "when kids think they're being taught, they shut off. But if they feel they're part of something fun and active, they absorb it without knowing it. To me, teaching is performance, and good teachers are performance artists."

So Seideman shares information, including geography (Yam Cakes from Africa, Paper-Wrapped Chicken from China) with his students, and considers his job well done "when the class leaves wanting to know more."

His advice to others who feel a similar compulsion? "Don't be a teacher. Just be yourself and share the excitement."

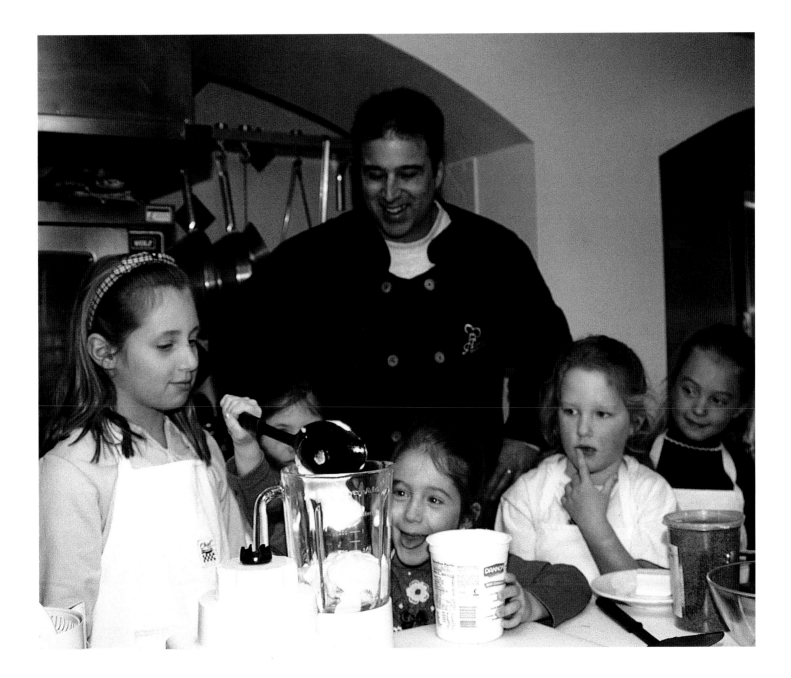

design. We've tried all along to make sure that the students really do have ownership of the project."

Which only makes sense, adds Manning, since kids have an affinity for the outdoors that their elders have sometimes lost. "Teachers tend to ignore what's happening outside the classroom walls," she says. "But the kids have an intimate experience going on outside all the time. They are the ones who see the dandelions blooming, the spiders, the water bugs. So this project is a way to honor their natural curiosity and connection to the local environment."

Moreover, the project's success has heightened both teachers' appreciation of hands-on, real-life experience. "It has become so clear to me," says Kane, "that kids learn best by being actively involved. My way of teaching has changed accordingly, and for the better."

"I'm all for breaking down the walls of the classroom," asserts Manning, "for extending outward and creating real-world understanding." In fact, Manning considers it a blessing that at the project's outset there was precious little actual nature to work with. "It gave us a chance to sit down and ask 'why.' And that led us to a very real understanding of what habitat means. Once we understood that, then we were in for a very remarkable discovery—that even young schoolkids can work on a real-life problem of habitat restoration."

Kane readily admits that she looks to Manning as her role model in this endeavor. "Margaret has

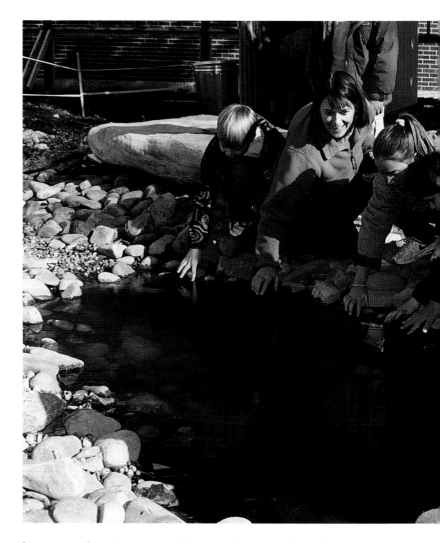

been a real environmentalist much longer than I have," she says. "I just try to keep up." Figuratively completing the circle, Manning claims that the students serve as her role models. "They are so naturally curious about the world and so unafraid to

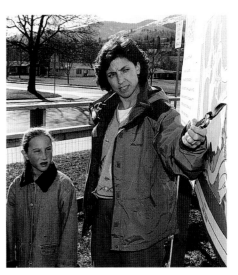

Habitat by the National Wildlife Federation, an achievement that has made both women justifiably proud. But both agree that much remains to be done.

"I would love to see the Discovery Core 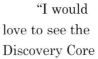 become an integral part of our school day and our school learning," says Manning. "Ultimately I would like to see us involved in conserving bird populations, restoring native communities, reconnecting to the environment, participating in decision-making processes that mirror the world beyond the classroom. Essentially, I see the Discovery Core as a microcosm of the issue of conservation in the West."

Kane, meanwhile, is carefully documenting the Discovery Core experience at Lewis & Clark. "I'm putting together a presentation and a slide show about what we're doing here so that we'll be able to share it with other schools and communities."

Outdoor Discovery Core is clearly an idea whose time has arrived.

take risks," she says. "That's my ideal. That's what I want to be like."

With the establishment of the Outdoor Discovery Core, Lewis & Clark Elementary became the first school in Montana to be designated a School Yard

Margo Toth

Second Grade Teacher, Elmwood Elementary School
Naperville, Illinois

"A good teacher finds the strengths in every student and figures out a way to bring them to the surface."

Margo Toth has a special incentive to encourage her second-graders to finish their work: they get to keep learning. Her classroom includes forty "learning centers," to which her students eagerly rush off once their regular class work is completed.

The activities embrace all subjects—from science to math to English to geography. "Some are easy, some are hard," says Toth, "but the important thing is that they get to choose what to do. That's the incentive, and that's what excites them—especially after a teacher has been telling them what to do all day long."

So forget pizza parties and M&Ms. "No," Toth explains, "we don't use that kind of reward. I tell my students that my job is to be the best teacher I can be and theirs is to be the best student they can be. And it really does work. They can't wait to go learn something else."

One of her favorites is a big rubber map of the United States, which often attracts the attention of more than one student at a time. "Teamwork is another aspect of the learning center experience," says Toth, "but the rule is that if they work with a partner they have to work quietly."

But not all of the learning activities invite teamwork; again, it's a matter of choice. "One of my students would rather read than anything else, so that's what she chooses to do. I have a little guy who almost always chooses the writer's workshop."

Speaking of reading and writing, Elmwood Elementary School stages a "read-a-thon" every February, and at the end of the month a famous children's author comes to spend a day at the school. The event culminates with an "author's tea," at which randomly selected students have the opportunity to meet the author close-up. "That's the kind of reward we like to give here," Toth declares.

This is one teacher who enthusiastically embraces current trends in education—particularly the emphasis upon hands-on learning and problem solving. "Twenty-five years ago we taught facts," says Toth. "Now we teach them where to find the facts. Also, everything in the classroom used to be black or white, right or wrong, but these days we realize that there are different ways of looking at things. It's really much better, I believe."

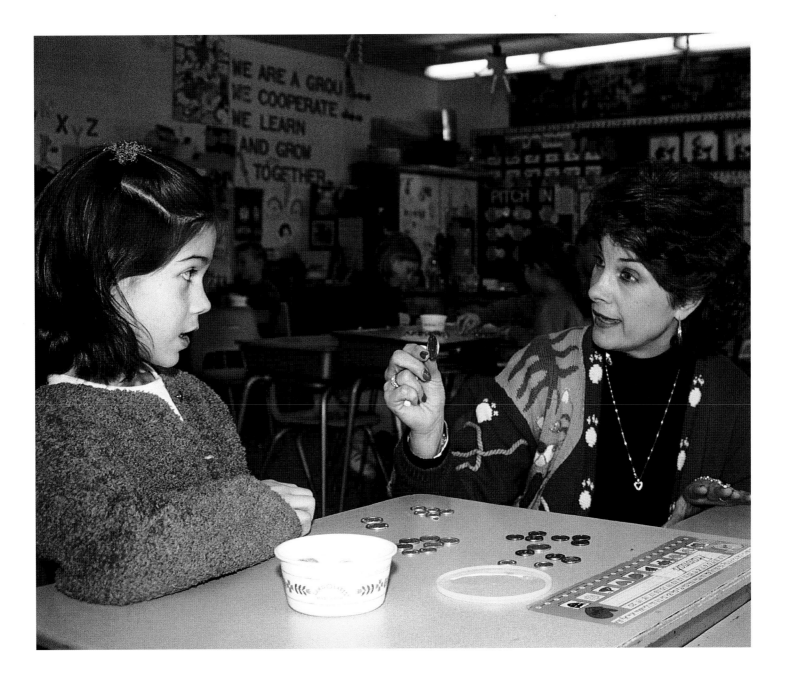

Harriet Ball

Educational Consultant, Musical Ball Points
Houston, Texas

"My belief is that your job as a teacher is to create a thirst in those kids. That's right! Make them thirsty—so they're dying to take that drink."

Harriet Ball was already fifteen years into her teaching career in Houston's elementary school system when she had her first strange epiphany. "My students were struggling to read numbers with more than three digits, and I was trying everything," Ball recalls. "All of a sudden my hand started writing on the board, just like on a Ouija board, and I started writing down a rhyme that explained how to change a written number to a numeral."

Ball had long been using oral cues—chants and call-and-response techniques—in her teaching, but this was the first time a song had come to her unbidden. "Other rhymes started popping into my head," she says, "sometimes in the middle of the night. They were revelations from God."

And they made her teaching, even in Houston's at-risk student population, spectacularly effective. Much of what she does can be defined as mnemonics, but she has better language for it. "When I teach, I employ the eyes, the ears, and the touching need, the movement need. It's Rap, Rhythm & Rhyme."

Students, once they get over the shock, respond wholeheartedly. "At first, it's like, 'What is she doing?

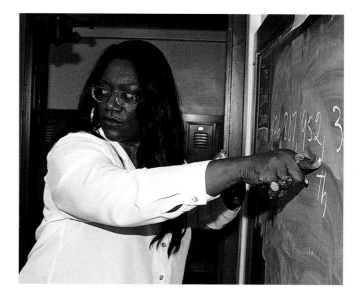

I haven't seen this.' Then it's, 'Oh, this feels good. It's all right.'" What's more, they learn, as their test scores confirm resoundingly. But was Ball's teaching style too idiosyncratic to be emulated?

In 1992, David Levin, newly graduated from Yale University, came to Houston's Bastian Elementary School as part of the Teach for America program. He floundered completely—until he noticed what was going on in Ball's classroom and asked her for help.

Michael Feinberg, a colleague of Levin's in another Houston school, was mired in a similar struggle until Levin convinced him to come and observe Ball's method.

The two converts went on to found two nationally acclaimed charter schools known as KIPP Academies—one in Houston and the other in the Bronx—which have been hailed by President Bush, among others, as fulfilling the promise of public education. The acronym, by the way, stands for "Knowledge is Power Program," which derives from one of Ball's inspirational chants.

"David asked me personally if they could take that as the name of their school, and I told them to go for it," says Ball. "I go up to his school in the Bronx once a year, and they are getting great results."

Once the KIPP Academies were founded, Ball found herself increasingly in demand as a workshop presenter. Retirement was still several years away, she figured, since her day job still paid most of the bills. Then one day at school, Ball says, she heard a voice. "I knew it was God. It said, 'Trust me. Here's your mission. I want you to go out and show more people your work.'" Ball promptly resigned—and was soon besieged.

Now Ball teaches other teachers—or sometimes their students—crisscrossing the country putting on seminars and workshops that showcase her "multisensory, mnemonic, whole-body teaching technique."

What makes her system unique, says Ball, is that she reaches the children who are turned off by school. "I do whatever it takes—singing, acting, clowning, even hugging. You've got to make school fun. So many kids you think have special education needs . . . and it turns out they don't. They're just different; they have a different way of learning. My method reaches those children, too."

Ball calls herself an "edutainer—half educator, half entertainer," and she loves what she sees on the faces of students when she has them under her spell. "It's their sense of gratification," she says, "and excitement, and then the knowledge that they really can learn. They're astounded, really, and that gives me such a natural high."

The response Ball gets from other teachers is not bad either. "The biggest compliment I can get is when the teachers, the math educators tell me, 'I wish I had had you. Where were you when I was in junior high?'"

Ball says teaching comes naturally to someone who loved—and still loves—to learn as much as she does. "I had a job working in my aunt's house," Ball remembers, "and she said, 'I'm not paying you to read my encyclopedias.' But as soon as she was out of sight, I was back at it. Her World Books, her Child Craft books, anything . . . I was just mesmerized."

This motivator extraordinaire demands from the teachers at her workshops the same high level of drive and commitment that she herself has been exemplifying for thirty years. "Good teaching is reaching each and every student and making excuses for none of them. Don't stop," she urges. "Go out there to get it.

Don't quit until you get it. And then improve on that."

If Ball concedes that her work is exhausting, she also claims that it's worth every minute. "You might feel like a beat dog at the end of the day, but you enjoyed it while you were getting beat. If I could have one more hour of energy, I'd head out the door again."

Chris Wilkins

Biology Teacher, Greenwood High School
Greenwood, Mississippi

"There's nothing for me like the joy of watching students light up and say, *'Wait! Don't tell me!'*"

Nobody promised him a rose garden. But when Chris Wilkins—raised in Rochester, New York, and educated at Cornell University—accepted a teaching job in Greenwood, Mississippi, he faced challenges that would have been difficult to predict.

Some come from the student body, kids who themselves face problems that "nobody should have to deal with," says Wilkins. "Some are coping with single-parent families. Mom has got two or three jobs, never home. They're looking after siblings. They're worried about staying alive, about crime and violence."

Some come from a system that seems little changed since the days of overt segregation. "It's still the same couple of very rich white families that own everything around here," says Wilkins, "while a huge number of black families live in poverty. And to make it worse, Mississippi has basically a dual school system. All the white kids go to private academies, and all the black kids go to the public school."

And, perhaps most frustrating, some challenges come from his fellow teachers. "There is tremendous cynicism and apathy among my colleagues," Wilkins declares. "They haven't changed in thirty years, and they see no need to change. They regard the diploma as recognition of twelve years of attendance, which is pretty disturbing."

But Wilkins passionately believes that, if he can rise to the challenge, his students can, too. In an environment where the accepted teaching method is "handing out worksheets," Wilkins takes his students to the nearby wildlife management area where they can actually experience biology. "I like having kids get their hands on stuff," he says. "They're more engaged, more interested, and they remember it longer."

While he's at it, Wilkins is changing the curriculum. "For the first time this year we have an environmental science class, and the kids have been fantastic about it. Now we can develop projects on things like habitat destruction, pollution, and mismanagement of ecosystems—things that matter."

Wilkins hopes he is making a difference in his students' lives. For sure, they have made a difference in his. "I've learned so much—to listen more, to worry less, to laugh when I can't think of anything else to do . . . and to change, to keep changing every year."

In fact, says Wilkins with remarkable candor, "I owe much more to Greenwood than I could ever give back."

Robyn Sturgeon

Math Teacher, Sussex Technical High School
Georgetown, Delaware

"When a student returns to say, 'Thank you,' it makes all the extra time and effort worthwhile."

Robyn Sturgeon's father, a math teacher, suggested that she apply her math aptitude to a career such as architecture or engineering. She wasn't buying. "I always knew I wanted to teach," says Sturgeon.

"I was inspired not only by the fact that math was my best subject," she continues, "but by the fact that it seems to be so many people's worst subject. I wanted to help people get over their math phobias. I wanted to find the fun in math."

The first step, Sturgeon believes, is getting students to recognize the math—especially geometry—in the world around them. "I'm always looking for real-world applications, hands-on experiences, and new ideas to make these concepts relevant," she says.

When she was assigned to write the curriculum for her school's new applied geometry program, Sturgeon saw a golden opportunity. As she contemplated what kind of project to develop, a colleague mentioned having seen a presentation on quilting at a recent math teachers' conference.

"I thought it was a great idea," she says, "even though I knew nothing about sewing." A second problem was time. "At first I conceived of this as a

year-long project, but then it occurred to me, 'Who wants a quilt in the summer?'" Clearly, if they did manage to produce any quilts, they would want them completed by Christmas. Despite the difficulties, Sturgeon's students "just jumped all over the idea."

Combining geometry and computer technology, along with history (to make historically-themed patterns), English (to keep a personal journal of the project), and art (to create colors and designs)—not to mention the basics of quilting itself—Sturgeon's class did in fact produce twelve quilts by Christmas 1999. The project was such a success that a second class participated the next year, and production soared to twenty-two quilts.

So, yes, the Applied Geometry Quilting Project is a perfect example of what Sturgeon calls "an integrated, standards-based, real-world application of geometry principals." But when her students present their quilts to hospitalized children at Johns Hopkins in Baltimore or the Shriner's Hospital in Philadelphia, it becomes much more. "These students put their hearts into giving to someone else for Christmas," says Sturgeon.

And that's a difficult thing to teach.

Maureen McQuerry

**Computer Arts and Sciences Teacher, Hanford Middle School
Richland, Washington**

"My advice to teachers is never measure your worth by your paycheck."

Lots of teachers tell their students to "be passionate" about what they're doing. Maureen McQuerry actually gives them the chance.

Having taught both elementary and middle school, McQuerry had noticed that most Gifted and Talented programs focused on the elementary level, thus leaving "highly capable" middle school students scant opportunity to fulfill their potential. Consequently, several years ago she developed a class called "Passion Projects"—created specifically to give students a chance to pursue something they are passionate about for an entire semester. By investigating their special interest, students are encouraged to conduct original research and connect with experts— mentors—outside of the classroom. The class concludes with a presentation at the end of the semester.

The projects have run the gamut: from a study of chimpanzees' use of sign language, to an examination of the role of women in Shakespeare's plays, to the design and construction of a medieval trebuchet with a seventeen-foot throwing arm (which the designers tested by hurling watermelons the length of a football field).

But certainly the most astounding project, to this point, has been the creation of *Nuclear Legacy: Students of Two Atomic Cities*—a 300-page commercially published, hardcover book with bilingual text, handsomely designed with full-color photography, co-created by eighteen of McQuerry's students at Hanford Middle School (home of the Manhattan Project) and by their counterparts in the city of Slavutych in the Ukraine (the city built to house those who fled from the Chernobyl catastrophe).

Harvey Wellman

Principal and Coach, Guthrie School
Guthrie, Texas

"We've got a wheat field over there, and in the fall of the year I've seen as many as a hundred deer out there grazing. It's different here."

Life is different in small towns—and even more different in *really* small towns. Guthrie, Texas, for instance—population, 120.

The whole of King County has 300 people in it, but since Guthrie is the county seat, it has the county's only school.

"We've got eighty students enrolled here," says Harvey Wellman, who has been at Guthrie for the last ten years of his thirty-six-year teaching and coaching career, "and I'm principal over all of them, kindergarten through twelfth grade."

Wellman's staff of seventeen teachers covers the gamut, from agriculture and homemaking to computer literacy. "We offer everything we can to our students," he says, "and our teachers are excellent." In this day of standardized testing, Wellman's school has reason for pride: "We've scored 'exemplary' for six of the last seven years."

On the football field, where Wellman is the coach, Guthrie has also excelled—though the game they play might not be readily familiar. "We play six-man football," Wellman explains. "The field is twenty yards shorter than in regular football, and everybody is eligible to catch a pass. It can get to be a real high-scoring game."

But even in six-man football, Guthrie fields one of the smallest teams in the state, says Wellman. "The most boys I've ever had on the team is fifteen, and one year we only had nine. Some schools have thirty or forty boys—enough for a junior varsity." Nevertheless, Guthrie has won several district championships and regularly qualifies for the state tournament.

How many athletes you have, Wellman believes, is not the important thing. "When I first came to Guthrie," he says, "they had the idea that they were too small to accomplish anything. But we got to work, and we've managed to change that attitude."

Wellman realizes—and preaches—that there is no real line between academic and athletic achievement, and he is a firm believer in Texas's "no pass–no play" rule. "When I first got into coaching, I thought it was a terrible rule," he says. "I thought I wasn't going to have any athletes. But I've come to see it's a really good rule. It stresses what needs to be stressed."

After all, says Wellman, "it's a very difficult world out there beyond Guthrie, and these kids are going to need brains—not football—to make a living."

Sarah Sink

Physical Education Teacher, Cave Spring High School
Roanoke, Virginia

"My advice to teachers is 'love it or leave it.' There's nothing worse for students than a teacher who doesn't like her job."

Sarah Sink, who has been the Physical Education teacher at Cave Spring High School in Roanoke, Virginia, for the past forty years, subscribes to the "teachers are born" theory. "You have to have that innate thing inside," says Sink. "In my case, I loved sports, loved performing, and I also always had to be the one in charge. So being a P.E. teacher was the natural choice."

For Sink, though, the question that begs to be asked is not why she became a teacher but why she's still at it—several years beyond typical retirement age. "I know this sounds silly," she says, "but I just really like the kids. Besides, I haven't run out of energy yet."

Not to mention the fact that Sink continues to be a phenomenally successful teacher, thanks to unflagging dedication and boundless creativity. At a time when most P.E. teachers simply "rolled the ball out," Sink built a dynamic and challenging physical education program from scratch. Along the way she started a gymnastics team and coached it for fifteen years. Her program has won two state championships.

Where the school lacks the resources for a formal team, Sink develops "clubs," as she has done in archery and boys volleyball. In addition to the curriculum's required P.E. courses, she has developed a "recreational sports" class, which includes field trips to firing ranges, bowling alleys, golf courses, caves, and rock climbing venues. It has become one of the school's most popular courses.

When Sink's not giving instruction, she's likely to be taking pictures and posting them on the bulletin board. "The pictures are a great incentive," Sink says. "The kids love to look at the picture of themselves. And I always make doubles, so the kids can take home copies of the ones they like."

Needless to say, all that Sink's work encompasses has required "many extra hours on the job" (twenty-four hours a day, according to daughter Lisa, also a P.E. teacher), but the rewards are lasting.

"I haven't tried to be popular," she says, "but by caring about them and showing them that I care about what I do, I have tried to earn my students' respect. If I have their respect, then I have a chance to influence their lives, and that, for me, is the ultimate reward."

Lisa Alison Sink

Physical Education Teacher, William Byrd Middle School
Vinton, Virginia

"I get up every morning looking forward to going to work. That tells me I'm doing what I'm supposed to be doing."

Lisa Alison Sink has paid her mother the supreme compliment. She has followed in her footsteps. Moreover, when asked why she became a teacher, she doesn't hesitate: "My mother is definitely the person who inspired me to become a teacher.

"My mother has always been progressive, ahead of her time, and really puts everything into the job," Sink elaborates. "You can tell that the kids really respect her and enjoy her classes, and I always wanted to emulate that."

And like her mother, Sink cherishes the opportunity to make a difference in her students' lives—especially the ones that seem like lost causes. "My mother and I are exactly alike in that way. The kids that the other teachers can't stand are always drawn to us. And I'm always drawn to them, too. In fact, at school they call me the P.E. social worker."

Which no doubt explains her emphasis on sportsmanship, camaraderie, and fun, rather than on the scoreboard. "I try to de-emphasize winning," says Sink, "and overemphasize sportsmanship. I like to give out prizes at the end of class to everyone who demonstrates good sportsmanship and consideration of others."

Sink's work is all about building stronger kids, inside and out. She wants her students to be not just physically fit but emotionally fit. That's why she makes sure to integrate activities like rock-climbing into the program. "A big part of climbing is confidence," she explains. "It doesn't do as much for the cardiovascular system as it does for the mind and spirit. Reaching the top is an achievement they feel proud of."

That's why, this past year, Sink has made her entire room a bulletin board. There's a place on one wall for kids to write in their names if they've made the honor roll. On another they can put up pictures of their friends. On another they can write down the titles and authors of their favorite books or their favorite musicians. "It's just my way of letting them express who they are," explains Sink. "It's a way for them to say, 'I own this room, these are my accomplishments and interests, and I'm comfortable here.'"

Sink is comfortable there, too. "You have to enjoy what you do," she says, "and I'm happy to say that I love my job."

Judy Gulledge

Science Teacher, Northside Middle School
Norfolk, Virginia

"We are all learning to teach better, whether we've been at it thirty years or one year. I know that next year I'll be a better teacher than I am now."

A few years ago, on a field trip to the Chesapeake Bay, Judy Gulledge and her students heard an environmentalist explain how important oysters are to the bay's ecology. Back in the classroom, they watched a PBS special on the bay's "watermen" which took the opposite point of view. When her students asked, "Who's telling the truth here?" Gulledge's response was, "I don't know. Let's find out."

After several months of investigation and still no clear resolution of the issue, they held a forum on the subject at a convention center in Norfolk. Politicians, environmentalists, fishery scientists, and watermen were assembled, and for two hours these experts fielded questions from three hundred seventh-graders from throughout the district. They learned first-hand, says Gulledge, how complex these problems can be, but one fact was indisputable: Chesapeake Bay today has 1 percent of the oysters it had a century ago, and that was enough to convince Gulledge's students to become advocates for oysters.

This anecdote says much about Gulledge's energy, vision, and teaching philosophy. "I never want to limit myself or my students, by saying, 'Oh, we can't do that.' I always try to think of a way," she says. "Whatever it takes is worthwhile if you're trying for something that will make a difference to the kids you teach."

So it's not surprising that the decision to become oyster advocates led to the creation of a class AquaLab, in which the students planned to grow oysters. "Then we learned," says Gulledge, "that raising oysters meant raising algae and everything else needed to feed them, so instead of a closet with one small tank, we ended up—once our principal saw the kids' enthusiasm—with a whole classroom full of tanks and a new fascination for hydroponics and aquaponics."

AquaLab, in turn, led to receipt of a $300,000 grant to fund the Maritime Studies Pathway project, which integrates elementary, middle, and high school students in an interdisciplinary study of marine science—one of the goals of which is oyster reseeding of the Chesapeake Bay.

"It all starts with the curiosity of students," says Gulledge. "They ask questions and we learn together."

Often this curiosity is whetted by the three-day field trips that Gulledge makes sure every student

Amy Miller

Director of Education, Dolphin Research Center
Grassy Key, Florida

"Practice what you preach. If you really believe in what you teach, your message will take flight."

Amy Miller is one of those fortunate people who get to do the right thing while living in the right place. She is the education director at Dolphin Research Center, located on gorgeous Grassy Key, Florida, halfway between Key West and Key Largo.

"The Everglades could possibly tempt me to leave here," says this hardcore naturalist and educator, "but the Keys are definitely beautiful."

Miller had to travel from the top of the United States to the bottom to take the job at DRC, but she's glad she made the trip. With a degree in Natural Resources and Marine Ecology from Cornell University, she was looking for a teaching job in the Northeast when a friend told her about an opening at DRC. "I was actually more focused on sharks and invertebrates, but when I realized how strong the conservation message was here and how effective dolphins are at inspiring people to want to make a difference to the oceans, I was sold."

Miller's special combination of interests, however, predates her studies at Cornell University. "My mother was an elementary school teacher, and from the time I can remember we used to look for the flower fairies in Cicely Mary Barker's *Flower Fairy* books. By the time I was eight or nine not only could I identify maybe a hundred wildflowers and trees, but I had also learned that experiential education is the way to go."

At DRC's special DolphinLab programs, Miller has the perfect opportunity to combine her passion for the marine environment and her commitment to hands-on teaching. DolphinLab offers college credit for its week-long courses devoted to the study of dolphins, marine ecology, and related environmental issues, and it makes learning an adventure with its combination of seminars, observation, and participatory activities centering on its colony of seventeen Atlantic bottlenose dolphins.

Steven Jacquier

**Science Teacher, Southwest Regional School District,
Togiak, Koliganek, Manotak and New Stuyahok, Alaska**

"Answers should only raise more questions. And if you're not making mistakes, you're not risking enough."

Steven Jacquier's career confirms that a life of science is—literally—a life of exploration. He was a student at Jamaica's Discovery Bay Marine Lab, performed research in Indonesia, helped build a shrimp hatchery in Ecuador and a school in the Himalayas, and studied ecology in the Galapagos Islands.

But during his work in South America, Jacquier made an unexpected discovery. "As an industrial scientist," he explains, "I was often asked to judge science fairs at the American school. Seeing the kids light up as they understood the concepts they had studied with their experiments, and seeing the pride (on the faces) of the teachers, made me realize that these people have meaningful lives. These teachers are making a positive difference." Already planning to move to Alaska, Jacquier enrolled at the University of Alaska at Fairbanks and was certified as a public school teacher in 1990.

His teaching duty is far from ordinary, however. As part of the innovative Effective Rural Model School, Jacquier spends twelve weeks per year in each of four different village schools.

"It's a tremendous program," Jacquier explains, "because it brings to these remote rural schools expert instructors who go from class to class with the same students integrating all the material through their particular specialty. So students who would otherwise not have exposure to specialized instruction in different disciplines are able to get that instruction. It's really a huge advantage."

Jacquier's approach is strictly hands-on. "I hope to invite students into a process of discovery," he says, and nowhere is this philosophy more evident than in the "clinical trials" his classes conduct on Fetal Alcohol Syndrome. "I saw the problem first-hand," he says, "in the schools and communities, and wondered what I as a teacher and scientist could do to help. The answer was to have students become junior scientists conducting a laboratory experiment where we actually induce Fetal Alcohol Syndrome in laboratory mice. So instead of just having an article or a booklet saying 'Don't drink—it causes FAS,' the students are creating the message themselves. They have ownership of it. Suddenly, it's meaningful to them.

"You've got to believe that in your own sphere of influence, however large or small, you can effect positive change," this intrepid teacher says wholeheartedly. "Because when you give up, the world dies with you."